The Inner Goddess

In memory of
Paul and Mary Richard
who first showed me
The Way

The Inner Goddess

Feminist Theology in the
Light of Catholic Teaching

Josephine Robinson

Gracewing.

First published in 1998

Gracewing
Fowler Wright Books
2 Southern Ave, Leominster
Herefordshire HR6 0QF

ISBN 0 85244 395 1

Typesetting by
Action Typesetting Ltd, Gloucester, GL1 1SP

Printed by Redwood Books Ltd
Trowbridge, Wiltshire, BA14 8RN

Contents

Introduction

The rhyme by E.C. Bentley made it plain:

> Geography is about Maps
> And Biography is about Chaps.

So what is theology about? Still more, what is *thea(o)logy* about? Is *ekklesia-logy* different from the history of the Church? Is *Gyn/ecology* allied to obstetrics, or is it just a fancy neologism? These are the questions I found myself asking and this book is something of an adventure trail as I tried to find the answers.

The contribution of women to the life of the Church is much debated at the present time. The Holy Father, Pope John Paul II, has stressed both in his *Letter to Women* and his encyclical *The Dignity and Vocation of Women* the part played by women's faith and works in the life of Catholic Christianity, a contribution almost as various as the women themselves. Feminist writers, however, favour a different emphasis. The Church claims to derive her authority from her fidelity to the gospel, guaranteed by Christ's words to Peter, 'On this rock, I will build my Church and the gates of the underworld can never hold out against it. I will give you the keys of the kingdom of heaven' (Matt. 16:18–19). Is it true that feminist theologians are not reassured or comforted by the rock that is our fortress? (cf. Ps. 18)

Theology, says St Augustine, should be done on one's knees. This study demands fidelity and humility, because, while the faith is inexhaustible and reveals new riches in each century, the pursuit of theology is not a

dispassionate matter and its practitioners, male and female alike, can run into murky alley-ways, leading to dead ends. So in this book, I shall consider the writings of some Catholic feminist theologians and seek to trace their relationship to the teachings of the Church in Scripture and tradition.

The way in which feminist theologians approach their discipline must be the first subject for consideration. Next come the responses of some writers to the Old Testament, to Christ himself, and to Mary, the Mother of God. I shall then look at liturgies written by women (in most cases), in the feminist cause, and at the question of the ordination of women to the priesthood. The two following chapters consider the matter of maleness and femaleness and how men and women relate to God, while Chapter 9 pursues 'green' matters. The last section explains the title of the work.

In writing this book, I have always to keep in mind the fact that unless I keep close to the Gospels and the teachings of the Church, I am as likely to go astray as anyone.

1

Feminist Approaches
to Theology

*What weight of ancient witness can prevail
If private reason hold the public scale?*
John Dryden

Rosemary Radford Ruether, an academic theologian in the USA, asserts that the critical principle of feminist theology is the promotion of the full humanity of women. In her book *Sexism and God-Talk*,[1] she explains that she is trying to recapitulate the journey of Western consciousness from the viewpoint of a feminist, so that her readers can see what has been lost to humanity through what she sees as the subjugation of women. She catches a glimpse of the new humanity which she hopes will emerge, through what she calls the 'affirmation' of the full 'personhood' of women.[2]

With that statement, the Vatican II document, *Gaudium et Spes*, subtitled, *The Church in the Modern World* agrees, though it includes men as well as women. It recognizes that there is a basic equality between all men and it must be given ever greater recognition. ('Men' is here used inclusively.) Paragraph 29 states firmly that discrimination in basic personal rights must be curbed and eradicated as incompatible with God's design. It describes as regrettable the fact that in some places women are denied the chance to choose their own husbands freely, to decide on a state of life, or to have the same educational and cultural benefits as are available to men.

Ruether reveals, without any subterfuge, that feminist theology is less concerned with women's relationship with God than with women's position in society. She develops this idea by saying that the uniqueness of feminist theology lies in the fact that women claim full humanity – which she sees as the critical principle – for themselves. It is true that certain women in the late twentieth century voice demands of various kinds. However, Christianity has never denied that women are fully human, so in order to make sense of Rosemary Ruether's statement, we need to have her definition of 'full humanity', of 'critical principle' and the significance of women's claims. She contents herself with saying that 'what we' – by which she presumably means all women – have always known, is the experience of being put down or being pushed to one side. Dorothea McEwen, quoting with approval the theologian Mary Hunt, expresses the belief that the demands of women, be they Christian, Jewish, Hindu, Moslem, pagan or goddess-worshipper have already changed the faces of different faiths by their insights and requirements.[3] She sees it as a recent and welcome development.

As far as Catholic Christianity is concerned, this is manifestly untrue in matters central to faith. Women have always made great contributions to Catholic life, and it is strange that these writers should ignore the long tradition of women fearless in the service of the Lord. In the lifetime of Christ himself, women walked with him, stood at the foot of the cross, went to the tomb to fulfil the customary rites for the dead. Women were martyred in post-apostolic times; women religious instituted the tradition of learned piety and were concerned for the poor, nursed the sick and taught the children. In millions of homes, rich and poor, women have passed on the faith. In all these spheres, they have given life, energy and talent in their work for Christ. The face of civilization, in as far as it retains, in some form, the grace of Christianity, would look vastly different without the loving work on women. They could hardly have done all this without awareness of their full humanity. Women

have often been treated badly, even in our own culture, but so have men, and although in some cases, men of the Church may have been the perpetrators, the teaching of the Church has neither incorporated it, nor justified it.

Definitions of Theology

If feminist theology makes women the defining principle, the simplest dictionary definition reveals God (Gk. *theos*) at its core and word, message, reason (Gk. *logos*) alongside. The classical definition of theology is identified with Anselm's words 'faith seeking understanding' (*fides quaerens intellectum*), because understanding requires an object – something understood.[4] Though it is impossible to attain full knowledge of God, he can be seen as what is intended in our questioning. This is the perception of Bernard Lonergan, the Jesuit theologian and philosopher, who died in 1984, and is a liberating insight.[5] God is not presented as having limits (that is, being an object[6]), but the desire for meaning leads us to ask questions and look for answers, and this search leads us to God.

Aquinas defined theology as the science of God and the object of the science is first God himself (*Deus sub ratione deitatis*); and then created things in their relation to God, who is their beginning and their end.[7] We are not, as Catholics, bound to accept these definitions, but it is surely significant that both refer directly to God as Creator and as the object of our faith, and only secondarily to humanity. Not all theologians appear to accept this. Thus Ruether does not refer to God as the critical principle, nor to any other concept of theology. Indeed, one is forced to wonder why she uses the term at all since one cannot escape from the deduction that a 'theology' which is primarily concerned with the position or social acceptance of women is a contradiction in terms. Semantically, theology refers to God.

Just as some feminist theologians deduct the concept of God from theology, so we find that the vocabulary of

feminist theology sometimes makes use of the term 'non-redemptive' to describe any act or idea which is seen as detrimental to women. The doctrine of redemption is central to Christianity. To use it as a synonym for 'improve' or 'ameliorate' is to parody and at the same time trivialize the doctrine, which will be looked at in more detail later. Lewis Carroll's Humpty Dumpty comes to mind. He maintained that his words meant whatever he wanted them to mean, neither more nor less.

Women's Experience and Theology

Feminist theologians depend on women's experience to define truth. They complain of patriarchal teachers who expect individuals to fit into the moulds they prescribe. They make it a principle and a boast that feminist theology is based on lived experience, starting with that of the individual. Mary Grey, who is a married, lay woman, and former Professor of Contemporary Theology at Southampton University, is said to have felt dismay at theology which did not fit what she personally had experienced.[8] Dorothea McEwen implies that no one but a fool would choose to follow somebody else's code of conduct, rather than one based on personal experience.[9] She claims that poor women in South America have redefined what the Church is, in terms of their rejection of the Church's teaching on openness to life in marriage. That statement is mistaken on two counts. First, the doctrine of the Church is not altered by democratic vote, nor by defections, as any Catholic should know. Second, despite much propaganda, and aid tied to population control programmes and the like, the number of children per family in South American countries is higher than in the affluent West.

Experience is their watchword – experience of the divine, experience of others, of society and particularly experience of oneself. Ruether accuses systems of authority of trying to dictate what can be experienced and how it is to be interpreted. The implication of this

perception is that all women have similar experiences, to which they react in similar ways, or that God takes millions upon millions of forms – a God for each woman. Unfortunately for the theory of female identity, women do not react in one way alone to the same experiences. Mary Grey allows that the poor, Jews, lesbians, blacks and others are divided by their experiences – but confines these to experiences of oppression.[10] The UN Conference on Women in Beijing in September 1995 revealed the unedifying spectacle of many mutually hostile groups of women, clamouring and campaigning for widely differing objectives, some traditionally Christian, others anything but. In response to the talk of women's experience, we have to ask, 'Which women? Which experience?' When T. S. Eliot made Sweeny Agonistes reduce the life experience to birth, copulation and death, he was deliberately trivializing it. There is more to life than the series of hatches, matches and despatches which appear in the personal columns of newspapers. Faith, or the lack of it, health or sickness, poverty or riches, love or lovelessness all contribute to the myriad variables of human existence, in women as in men, in which heredity and nurture both play a part.

However, our life is not made up only of discrete experiences, divorced from the life of others of our kind. The most popular image of the Christian world, one to which most women in all cultures would also respond, is that of mother and child, because the love of mothers for their children is inherent in their nature. We see on our television screens pictures of the most deprived people on earth, refugees, starving and disorientated, whether from Bosnia or Sub-Saharan Africa – and we see mothers trying to succour their children. Yet, paradoxically, feminist theologians give scant consideration to this most female concern. Most would admit that biological differences are not wholly irrelevant. Women who have given birth and breastfed their babies have certainly experienced what is unique to women, as these writers cannot but agree. Rosemary Ruether glancingly refers to bringing up children as culturally valuable. But she

laments that women are seen as 'reproducing' (sic) children and producing cooked food and clothes for men. Despite the evidence from top chefs and dress designers, she alleges that men regard this work, essentially and in all circumstances except an occasional feast, as beneath them! She seems to go along with what she assumes is the male point of view, when she speaks of the 'burdening' of women with most of the tedious, day-to-day tasks of economic production.[11]

Elisabeth Schussler Fiorenza,[12] in something of a gloss on Ruether's complaint, writes that in our faith as Christians, which involves our concerns for human beings, 'We are she: bearer and bone, mother and child. We are the Christa.'[13] The awkward phrase 'we are she' is presumably meant to convey a mythic quality to all women who are mothers. Apart from the attractions of alliteration, it is not clear why Fiorenza chooses the words 'bearer and bone' in juxtaposition. Does she mean that the child is 'borne' (carried) by the mother? Why are mothers considered as 'the saviour' – which is the Greek meaning of the word 'Christ'. The whole sentence sounds like a complaint. There is appalling presumption in identifying mothers with a female Christ. It seeks to empty Christ of his reality and mothers of theirs. There is only one Christ and he was male. In their different ways, both these statements are irreconcilable with the teaching and tradition of Christianity.

Schussler Fiorenza sees women as forced to live their lives through their husbands and children. She says this in her book *Discipleship of Equals* which was only published in 1993, but this statement certainly has a period ring to it.[14] Women in the Western world, for better or worse, are able to live autonomous lives, pursuing their ambitions in the public sphere. Nothing in our society obliges them to stay at home if they can find a job to go to and a nursery for the kids. In fact, the pressure is on them to go out into the world. She, however, believes that women have colluded with the idea of their inferiority, often defending it in the guise of the feminine mystique. She sees the concepts of obedience and submis-

sion in Christianity as turning women against themselves, internalizing their negative beliefs about their individual worth.

It must first be stated, that in Christianity, the necessity of obedience and submission is not confined to women! Our Lord is an even greater exemplar of this than Our Lady! It must also be said that the notion of the Angel in the House as a cultural norm for our time is ludicrous.[15] More serious than that error, is the fact that it does not seem to occur to feminist theologians that bringing up children is a task of the very highest importance from both a religious and social point of view. What other artist has human beings as their material! The home is both domestic church and domestic school. The sense of security and belonging that small children receive from their parents and especially their mother, is their first essential lesson in human personhood – and it takes time to teach it. It is the mother who has shared her life with the new life in the womb, who can best accustom her baby to the big world outside. The joy that one sees on the faces of new mothers is their reward.

Are There Objective Sources for Theology?

Working from her belief in the primacy of individual experience, Rosemary Ruether maintains that all theologies are 'experimental' and that codified, collective experience is what makes up so-called 'objective' sources of theology, Scripture and tradition.[16] According to F. C. Copleston, the Jesuit philosopher and authority on Aquinas, St Thomas would agree that one tries to establish a hypothesis about events or ideas and their causes, but one cannot claim definitive answers. Our efforts to provide them are thus experimental.

The primary source of knowledge resides in our senses – we hear the gospel; we see the words in the book. Nevertheless, we are not limited to the experience of our senses, because we are able, by our powers of cognition, to perceive similarities and differences and thereby frame

a hypothesis. In short, experience is not enough; discernment is also necessary. You may remember that Christopher Robin, in the poem by A. A. Milne, confides that he avoids being attacked by the bears, who lurk in dark corners of London, by not walking on the lines of the pavement. That is his experience – he has never encountered bears while following this routine – but it can be readily seen that he is omitting another, logically coherent possibility! It may even be that there are no bears in London, outside the zoo![17]

Many feminist theologians reject the idea that outside authorities can interpret experience for us. As we saw above, all experience has to be evaluated in a context of understanding, otherwise what we perceive in half light to be an animal may turn out to be a bush; what looks like an angry grimace may be a smile. We have to accept that Christianity is a special case. The Church, as an organic system of authority centred on the Pope and the bishops, derives that authority from Christ himself and from the continuing presence of the Holy Spirit. That is what the Church has said from the beginning. She believes that she has a God-given duty to teach and guide in the moral sphere. She is to draw people to Christ, so that they become disciples: they can be confident that her teaching is authentic. In the matter of Revelation, it can be argued, the Church alone enables us to evaluate our experiences with certainty and so break out of otherwise confusing and claustrophobic personal worlds. As Aquinas says, the knowledge of the senses is not the sum total of intellectual knowledge. Therefore it is not strange that intellectual knowledge should extend further than sensitive knowledge.[18] Like the Ethiopian eunuch in Acts 8, we need a guide to help us interpret what we hear or read and even what we feel in prayer and worship. As Philip was to the eunuch, so is the Church to us. The alternative is a Church constructed in the imagination of each individual. One is reminded of the story of the old Scots lady who, having quarrelled with all the clergy in the neighbourhood, founded her own church with her coachman as congregation. When she was asked by one

pastor, in a last desperate attempt to bring her back into the fold, if she really thought that only the two of them would get to heaven, she replied 'Well, I'm not so sure about Hamish!'

What is Revealed and What We Feel

As we have seen, feminist theologies start with the individual and her life, and suggest that all women undergo similar sufferings. Rosemary Ruether suggests that ideas about religion derive from an experience which reveals something new. The 'new thing' does not come from a Road to Damascus encounter, but it provides symbols or metaphors for living. However, she makes plain that the personal view is to be validated by the experience of society – presumably, a society of women. This brings to mind the consciousness-raising methods of liberation theology in socially deprived countries of the Third World.[19] It leaves her vulnerable to the charge that she has no method to distinguish the authenticity of the Holy Spirit's descent on the apostles from 'Pentecostal' experiences, including the hysteria of the so-called Toronto Blessing. She does not have a yard-stick to evaluate religion.

In the tradition of the Catholic Church, revelation is presented as an utterly free gift from God to man; part of God's plan, from all eternity, to reveal himself to man out of love, in the person of his Son, Jesus Christ, through the Holy Spirit. The two approaches are dissimilar and Ruether moves even further from the classic definition of revealed truth by stating that through women's experience (a questionable concept, as we have seen), theology becomes sociology, de-mystified, subjectified and thereby removed from final authority. God is not 'out there' at all, but within the individual, who has only to look into her heart to know God. Chesterton said he liked the dog, as long as he was not spelled backwards! The fear is that whatever we want will be spelled 'God'. For feminists, it seems God can be spelled anyway one likes.

Dorothea McEwen agrees that feminist theology, like all theology, is based on experience. The difficulty with this judgement is that it is finally incompatible with the way in which the faith has been handed down for nearly two thousand years. What personal experience would lead us, inevitably, to the doctrines that are part of Revelation? But personal experience does confirm certain truths that we have to be taught initially, for example, that it is better to give than to receive. On the other hand, it is difficult to imagine the circumstances in which one would arrive autonomously, at the doctrine of the Trinity, for example. The story is told of a religious sister explaining a new system of catechetics to the parents of her class. She said she would not be mentioning the Trinity because the children were too young to understand it. At which a father put up his hand and said politely, 'Can you tell us, sister, at what age one can understand the Trinity?' There are mysteries here.

A number of feminist writers refer to pairs of opposites in terms of good/bad, and male/female, rather as George Orwell's creatures in *Animal Farm* are taught to think 'Four legs good, two legs bad'. They do not, of course, accept the interpretation that male equals good and female bad, but they think that these ideas are subtly promoted. Schussler Fiorenza speaks of traditional theology as combined with a male/female dualism (mind as male and body as female). Thus the female, as body, has always to be subordinate to the male, as mind.[20] Ruether goes further. She says that feminists should not accept the 'good/evil dichotomy'. She describes as the basic error of 'patriarchy' that the 'dialectics of human existence – male/female, body/consciousness, human/ nonhuman nature – are turned into good/evil dualisms' and that these translate into masculine power and *andro- centrism* (that is the centrality of the male).[21] There is also a tendency among such writers to iron out the distinction between human beings and animals and to stress the affinity of women for trees and growing things. Do they really believe, as some of them say they do, that nature

suffers when we suffer? The pathetic fallacy has a long history. Though inanimate nature cannot feel, there is perhaps a certain truth here, in that the only way in which we can make sense of natural disasters is to link them with the aftermath of the Fall of man through disobedience. The result of man's treachery is felt throughout the entire cosmos and man guards himself against nature. As Gerard Manley Hopkins wrote, 'Nor can foot feel, being shod.'[22]

Rosemary Ruether, for one, rejects what she describes as any standard of humanity, whether Christian, white, rich or Euro-American. Her use of the word 'standard' is curious, because, whereas, of course, all human beings are equal in God's sight, the standard of humanity for Christians is Christ. She further urges women to reject the idea that human beings are the crown of creation and that animals, plants and stones are inferior. Does this derive from her feeling for the natural world, or does she believe, like the pantheists, that God and his creation are one? I daresay in practice she swats flies, like the rest of us. Genesis states firmly that it is only man (male and female) who is made in the image and likeness of God and that he has a duty of care for the world that God has entrusted to him. In fact, we all know that it is not only because animals cannot cook that human beings are superior. Animals lack the self-awareness that enables human beings to stand back from their experiences and evaluate them.

Rather touchingly, Ruether writes that she sees women's resistance to what is popularly known as 'sexism' as a struggle to make all mankind better, to save the earth and to be in accord with the God/ess. (The latter is Ruether's own coinage intended to indicate that God in the future will comprise both masculine and feminine.) This good-hearted optimism underlies her ideas.[23]

In something of the same vein, Luce Irigaray, a French psychoanalyst, quoted by Schussler Fiorenza, believes that God should be a couple, male and female, in order to remove imbalance. Of the title of Schussler Fiorenza's book, *The Discipleship of Equals*, Irigaray asks who is meant

to be equal to whom – to God or to males? Since God created both male and female, Irigaray sees sex as part of the divine.[24] Fiorenza scouts all this. She wants to promote a just and equal world, freed from the oppression of the patriarchal society. She wants everyone to participate equally in a great assembly, as part of the *Basileia*, a vision of God's alternative world, including, she says, even bishops. Humanity being what it is, one cannot escape a feeling that even here, some would be more equal than others.[25]

Groupings in Feminist Theology

Feminism comes in different flavours and groupings are inevitably fluid, but certain themes bind some of them together. Elisabeth Schussler Fiorenza quotes, and partially rejects, the categories produced by Fr Francis Mannion.[26] It is worth saying here that feminist movements are much more widespread and visible in the USA than in the United Kingdom (or, I suspect, elsewhere in Europe). Many of them form part of the Church's bureaucracy and they publish more books, writing mostly from academic chairs, so that their influence can be readily imagined. Rosemary Ruether is the favoured guest speaker at conferences of the small, but influential, Catholic Women's Network in the United Kingdom.

Catholic women may well feel deprived of the name 'feminist'. It has effectively been taken from us. Many of us certainly want to improve the position of other women in all communities. In our own society, we are struggling against its corrosive pressures on women to destroy their pre-born children by abortion, their marriages by divorce (well-prepared for by the ridiculing of chastity and the pressure for contraception) and the corruption of their children by humanistic sex education in schools. We lack a campaign title. In other societies, women may need urgently to work for the basic human rights to education, property, the removal of arranged marriages and so on. If 'feminist' is tainted, we have no right to use the word

'*womanist*' either, because it is used by black American women to name their own specific struggles.

Most Catholic women want to thank God for the gifts he has given them. To be a woman is to be someone centred in her own personality and able to bring characteristic qualities to all aspects of life. It is, typically, to be gentle and kindly, in harmony with the soft curves of her body, her grace of movements and charm of voice. It is to have the possibility of bringing new life into the world – and motherhood can be spiritual, as well as physical.

Fr Francis Mannion, who was writing about the USA, mentions first 'affirmative' groups, who follow Church teaching with glad assent. Schussler Fiorenza does not deem them worthy of the name feminist. The second category which he calls 'corrective', has the same values but is less conservative. He places the US bishops in this category on issues concerning women. On the sliding scale, he next places 'reformist' feminists, who, in his view, translate secular feminist ideas into the theological or ecclesiastical sphere, upholding 'personal liberation', however that is interpreted, seeking the advancement of women in the Church, but stopping short of ordination. Alarmingly, he places the National Abortion Rights Action Campaign in this category. The last two categories, he describes as 'radical'. 'Reconstructive' feminism contains the usual aim of changing society at its roots, holding that patriarchy (always seen as bad in all circumstances) and discrimination in terms of race and sex are an inevitable part of the way in which society is constituted at present. They turn to Matthew Fox's Creation Spirituality and New Age rituals. The final category Mannion calls 'separatist' and Rosemary Ruether 'romantic'. Its proponents react against the scientific and technical mindset of the modern world. They reject all existing institutions, and promote goddess-worship and witchcraft. Its proponents want as little as possible to do with the male sex; they refuse to give them the benefit of any doubt. They turn from procreation by sexual intercourse to self-insemination by donor. Needless to say, they adhere to a moral code of their own devizing.

Schussler Fiorenza rules out the first two categories and in any case maintains that her own brand of feminism derives, not from the secular world but from the idea of God's kingdom, the *basileia*, the world of justice and salvation. We have to admire her optimism, knowing that the Church has to work with human beings in all their frailty and disposition to sin. In theory, we long for a life in harmony with all other people, while refusing to give up our selfish designs in practice. She characterises the *basileia* as a round-table meeting to which everyone is invited. Even in the equality of a round-table meeting, some make more noise than others![27] She puts great faith in the notion of everyone having their say, though it is doubtful whether she would be pleased if the *basileia* expressed orthodox Catholic beliefs. In any case, doctrine is not made from the ground up, on the basis of democratic vote, or group feeling. Perhaps, Paradise alone would guarantee an assembly without conflict.

Nineteenth and Twentieth-Century Influences on Feminist Theology

In political terms, feminism can be of the left or of the right. Liberalism fuels the most widespread form of feminism, which is predicated on moral relativism, and which forms the mindset of many males, as well as females, in contemporary society. They maintain that it is unrealistic to expect women to stick by ancient shibboleths. Since women, in particular, are closely concerned with personal relationships, family and home, it is these concepts that they seek to change. One must agree that there is no parity between male and female in sexual matters, when the possible consequences of the sexual act affect women physically and emotionally and need not affect men at all. It has been well said that either there is a profound spiritual value in giving birth or it is the damnedest injustice in the world! Many contemporary women have somehow lost the full sense of this value and depend on technical methods to give them the parity

with men in the field of sexual relations that they crave. It has also to be said that society and governments in the Western world do not provide the support that married couples need and deserve. Almost all feminists support the liberal agenda of personal *laisser faire*. Liberalism is rather acidly described by Rosemary Ruether as the preferred view of the bourgeois. They hope that equal opportunities in education and the workplace will produce a society of equals, while keeping private property in place.

On the other hand, Marxism provides a theoretical justification for radical feminists, as it seeks to overthrow the structures of society, which it understands as unjust. It became an almost universal creed in the middle and late twentieth century and it is only since the overthrow of the communist regime in the USSR that it has been discredited in the world of nation states. That said, it must be admitted that Marxist ideas still lurk in some form in many academic and Church institutions. In feminism, the oppression of private property has largely given way to the oppression of 'patriarchy' as the common enemy.

A totalitarian social model cannot admit the validity of religious faith, almost by definition – religion takes the 'totality' out of totalitarianism. Therefore, Marxism provides feminist theologians with an awkward ancestry! Many of them resolve this by redefining belief in God as something approaching belief in personal autonomy – a god or goddess within. This translates all too easily into the understanding that what 'I want' is of God.

Freud is another founding father of feminist theology, in that his emphasis on sex as the basic human drive is adopted by 'pro-sex' feminists. Kathleen M. Sands, in an article called 'The uses of thea(o)logy' says that we need a fine-tuned perceptiveness about the opposing forces that comprise our actual sexual lives and that, so far, the 'sexual wisdom of thea(o)logy is inhibited by our need to defend eros'. She describes sexual desire and pleasure as self-justifying and the banner slogan for 'pro-sex' feminists.[28] She does not seem to take a context for sexual acts into account.

Each of these influences derives from a male protagonist, but each has a feminist version and women partisans.

Many feminists passionately desire the happiness of women, their freedom from constraint and want – genuinely good things, which nevertheless prompt us to ask a lot of further questions. What do we mean by good? How can we distinguish the good from the bad in a given situation? What forms the basis of their judgement?

Notes

1. Rosemary Radford Ruether, *Sexism and God-Talk* (SCM Press, 1983), p. 18.
2. Ruether, *Sexism*, p. 45.
3. Dorothea McEwen, 'The Praxis of Feminist Theology', *Feminist Theology*, January 1995, p. 82.
4. Anselm of Canterbury, *Proslogion,* Proemium, in Wisdom of Catholicism, ed. A. Regis, Random House, NY 1949.
5. Bernard Lonergan, *Insight, Collected Works* (University of Toronto, 1992).
6. 'The object of our questioning' allows a broader understanding of 'object' than that of Kant and certain twentieth-century philosophers.
7. *Summa Theologiae*, 1a, Q. 1, art. 7.
8. Mary Grey, quoted by Moya St. Leger in review of D. McEwen, *Women Experiencing Church* (Gracewing), *Catholic Women's Network Review*, June 1992, pp. 11–12.
9. McEwen, 'Praxis', p. 82.
10. Mary Grey, 'Claiming Power in Relation', *Journal of Feminist Studies in Religion*, Spring, 1991, 7–10, p. 10.
11. Ruether, *Sexism*, p. 74.
12. A married academic, originally from Germany, but now teaching in America.
13. Elisabeth Schussler Fiorenza, *Jesus, Miriam's Child, Sophia's Prophet* (SCM Press, 1994), p. 3.
14. Elisabeth Schussler Fiorenza, *Discipleship of Equals* (SCM Press, 1993), p. 57.
15. *The Angel in the House* is a verse novella by the Victorian poet Coventry Patmore, which gives an idealized picture of a doting wife.

16. Ruether, *Sexism*, p. 12.
17. A. A. Milne, *When We Were Very Young* (Methuen, 1921).
18. *Summa*, 1a, Q. 85, art. 1, from *A Shorter Summa*, ed. Kreeft (Ignatius Press, 1993), p. 122.
19. Ruether, *Sexism*, p. 13.
20. Schussler Fiorenza, *Discipleship*, p. 97.
21. Ruether, *Sexism*, p. 15.
22. G. M. Hopkins, 'God's Grandeur', *Collected Poems* (Oxford University Press, 1948), p. 70.
23. Ruether, *Sexism*, p. 46.
24. Luce Irigaray, 'Egales a Qui?' a criticism of Schussler Fiorenza, *In Memory of Her*, *Critique* 43 (1987), 420–37.
25. Schussler Fiorenza, *Discipleship*, pp. 10–11.
26. Rev. Francis Mannion, whom Schussler Fiorenza describes as a 'relatively unknown' diocesan theologian, published an article entitled 'The Church and the Voices of Feminism' in *America*, October 1991.
27. Schussler Fiorenza, *Discipleship*, p. 11.
28. Kathleen M. Sands, 'The uses of thea(o)logy', *Journal of Feminist Studies in Religion*, Spring 1992, 8–21.

2

The Old Testament and Feminist Theology

God, thou art my God: eary will I seek thee.
Psalm 63

The Old and New Testaments form the written part of the living tradition which conveys the inspired word of God, being, as St John Chrysostom says, 'a letter written by our heavenly Father and transmitted by the sacred writers to the human race in its pilgrimage, so far from its heavenly country'.[1] Scripture and tradition, interpreted by the Magisterium are the guarantee of the guidance of the Holy Spirit to the Church on earth.

The Bible, however, is a complex library of documents, written through many historical periods by human authors, so that the reader cannot select gobbets and accept all of them as equally encapsulating divine wisdom. Many of the writers of the Old Testament, for example, had no idea of an afterlife. We see that God taught his chosen people slowly through time, with much remaining hidden, until the moment came for Christ to live as a man on earth. In other words, revelation was progressive, until, as the *Catechism of the Catholic Church* says, 'The son is the Father's definitive Word; so there will be no further revelation after him.' Before that time, under the old covenant, God showed himself incompletely.[2]

The Catechism of the Catholic Church and the Pontifical Biblical Commission on the Interpretation of Scripture

Biblical criticism is not a new thing. How to understand the concept of inspiration was discussed by St Thomas Aquinas and many others. But the realization that the books of the Bible were written by men, each in a particular moment, is comparatively new and it can easily lead to a sceptical approach to Scripture. We are told by the *Catechism* that divinely ordained revelation is bound up with deeds and words which shed light on each other. This was God's special way of teaching: he communicated himself to men step by step. St Irenaeus of Lyons often spreaks of God and man slowly becoming accustomed to each other.[3] This gentle, almost tentative approach to the interpretation of the Bible is developed in the Pontifical Biblical Commission document *On the Interpretation of the Bible*.[4] It acknowledges the value of the historical-critical method in that it tries to shed light on the 'historical processes which give rise to biblical texts' and the particular importance of *sitz im leben*, the placing of them in the context in which they were written, the consideration of whether they were set in a legal or liturgical setting, and the different categories of hearers or readers living in different places and different times, who encountered them. As the Vatican paper points out, one result of these developments in critical study has been to confirm that the documents of the New Testament in particular reflect the beliefs of the early Church, which were taken from the preaching of Christ himself.

Latterly, these methods have been supplemented by the study of the means used in editing the texts, which in turn have revealed much about the evangelists and other biblical authors. Rhetoric, the art of persuasive argument, and what is called 'narrative exegesis (that is, the study of the meaning behind a particular story), are also useful tools for understanding. Nevertheless, the document makes clear that such methods of biblical criticism are inadequate by themselves, though they have contri-

butions to make. Difficulties arise from the often unad-
mitted ideology of the critic. It goes on to note that the
sociological approach, allied to liberation theology (to
which feminist theology owes many of its ideas) tends to
emphasize a temporal outcome, which finally divorces it
from religion, while feminist theology fosters 'a
hermeneutic of suspicion'. This phrase is used by
Schussler Fiorenza among others and by it women are
enjoined to search religious texts for evidence of 'patri-
archism' and androcentrism (meaning 'male-
centredness') in order to reject them. It is like running a
metal detector over a possible bomb-site. Such an exer-
cise leads to the establishment of a 'canon within a
canon', effectively censoring texts for unsuitable material
and accepting as authentic only those which chime with a
particular viewpoint or agenda. At the very least, it leads
to a lack of balance in the consideration of biblical texts.
On the other hand, as the document itself reminds us,
history is usually written by the victors, so that careful
scrutiny is necessary!

In a significant passage, the Commission says:

> Feminist exegesis often raises questions of power
> within the church, questions which, as is obvious, are
> matters of discussion and even of confrontation. In this
> area, feminist exegesis can be useful to the church only
> to the degree that it does not fall into the very traps it
> denounces and that it does not lose sight of the evan-
> gelical teaching concerning power as service, a
> teaching addressed by Jesus to all disciples, men and
> women.[5]

Such it seems is the fear of feminists, that this mild and
sensible statement was not accepted by a minority of the
Pontifical Commission, who asked that their dissent
should be recorded – as it was.

Liberation theology, to which feminist theology often
runs parallel, considers biblical writings in a particular
social context and reads texts interpreted from a partic-
ular socio-cultural and political point of view, angled to
the social needs of the people. Although this can be

valuable, as the document points out, it carries the risk of emphasizing some texts, notably those concerned with oppression and injustice, at the expense of others.

Proper concern for the social order and the supply of material needs can unbalance or even overturn the essential relationship between man and his maker. One says this with hesitation because, in the affluent First World, we can have little understanding of the real deprivation of other parts of the globe though the Church has from early times been the agent of social betterment. Nevertheless, if everyone in the world had decent housing, enough to eat and a measure of affluence, their spiritual needs would still be paramount. The Gospels are more than societal game-plans. Rosemary Ruether favours a contrary view. She comments that 'In much of human history, the divine world has been used to sacralize the existing social order.'[6]

Feminist Approaches to Biblical Criticism

The founding mother of feminist biblical criticism was the redoubtable American Protestant, Elizabeth Cady Stanton. During the fight for women's suffrage in the USA towards the end of the nineteenth century, she published a work called *The Women's Bible*, a commentary, based on the belief that the Bible could not be seen as 'neutral' because it engaged in a political struggle against women's desire for liberation. Many American women at that time, belonging to various Protestant denominations, were engaged in schemes of betterment for the poor and were also involved in the temperance campaigns, the work for abolition of slavery and the 'purity' movement, which tried to help prostitutes and to eliminate prostitution. Some of them were veterans of pioneer and frontier settlements and they chafed at the restrictions they suffered in their work, as towns and cities became more structured. Contemporary women can empathize with their feelings, living, as we do, in a time of much greater freedom for women. The book

itself, according to Francis Martin, is a mixture of 'deism, rationalist Protestantism, devout Christianity and current culture'.[7] While understanding in part the power and strength of the Scriptures, she nevertheless dismissed the Bible as the work of males who never saw God.

In the 1970s, the 'women's movement' revived the interest in biblical interpretation. The Vatican document analyses the principal feminist schools, distinguishing three main approaches. There is the *radical* which sees the Bible as unacceptable because it was written by men in order to confirm the superiority and authority of the male over the female. The second group, described as *'neo-orthodox'*, endorses those parts of Sacred Scripture which speak of oppressed peoples, notably the Israelites in Egyptian captivity. They distinguish 'a canon within the canon', thereby accepting the Scriptures selectively and applying them to the alleged oppression of women. The third approach is known as *'critical';* it looks at New Testament texts in particular in order to distinguish the roles and status that Jesus accorded women.[8]

Patriarchy and Male-Centred Religion

The word 'patriarchy' comes from the Greek and means *the father-who-rules*. In the Old Testament, the patriarchs are Abraham, Isaac, Jacob, the twelve sons of Jacob, and David. The *Catechism* comments that these patriarchs, along with the prophets and certain other Old Testament figures are honoured as holy.[9] From the sixth century AD, the Church used the title for the bishops of Rome, Constantinople, Alexandria, Antioch and Jerusalem and they had the power of appointing bishops. Rome was always acknowledged as the first and foremost of these.

Elisabeth Schussler Fiorenza finds herself in a quandary with regard to the Old Testament. Patriarchy is enshrined in Judaic writings: to reject patriarchy is therefore to go against the Jews.[10] It does not seem to occur to her that there is no reason to go against the Jews and that perhaps the Jews were right and that there is a good deal

to be said for patriarchy in the right place. For Rosemary Ruether, the idea of patriarchy is idolatrous, in that it means that women are subject to men.[11] In fact, she sees such a society as determined by struggles between groups, king over subjects, aristocracy over serfs, masters over slaves, racial overlords over colonized people. This is an articulation of Marxist ideas, but it renders the term 'patriarchy' almost meaningless. Fathers are not the only ones who rule. Queens have been tyrants, as well as kings; colonial housewives have despised their servants on racial grounds; hen-pecked husbands attest to the existence of overbearing wives. Mothers-in-law are the stereotypes of the family battleaxe. The word 'patriarch' should not be used as a synonym for bully. Nor should all men alone be accused of domination, which is not wholly confined to the male sex, although as Pope John Paul II says in *Mulieris Dignitatem*, the male tendency to impose his will 'indicates the disturbance and loss of the stability of that fundamental equality which the man and the woman possess in the 'unity of the two'.[12] The *Catechism of the Catholic Church* describes the Old Testament patriarchs as being called and guided by God, lighting up the way of the promise.[13] In those times, it is not hard to imagine the value of a father-figure, holding the tribe together, dispensing wise judgements with mercy. Although the Old Testament is frank about the failings of the patriarchs, Abraham is still referred to in the prayers of the Mass as 'our Father in faith'.

With the wariness engendered by the hermeneutic of suspicion, Schussler Fiorenza warns against the glorification of women as well as their denigration: she understands both concepts as patriarchal and unreal.[14] She does not seem to want women to be in receipt of little courtesies, because she sees them as demeaning – and this feeling is common among feminists. However, such politenesses can be seen as an acknowledgement of women as bearers of life, whom men, strong in their manhood, wish to salute and care for. Women can afford to enjoy such attentions. Women in Old Testament times would no doubt have been glad of them.

Ruether admits that Christianity never completely denied that women were made in the image and likeness of God and indeed Genesis leaves little doubt about it. But she does assert that theology, which she sees as having been written by autocratic males, accuses women of being more likely to fall into sin and less likely to reach spiritual heights. She admits that this is mostly in popular diatribes. It certainly forms no part of the teaching of the Church. Even under Jewish law, women were encouraged by their rabbis to thank God for their womanhood – thus balancing the well-known prayer of Jewish males that they thank God they were not born as females![15]

The Case of the Good Wife

Schussler Fiorenza takes a less gloomy view than Ruether, arguing that patriarchal law was more restrictive in theory than in practice. However the laws were framed, women were not perceived as the equivalent of minors or slaves in everyday life. As she notes, the Good Wife in the Book of Proverbs (31.10–31) had a wide field of endeavour and her business sense and enthusiastic initiatives are accepted almost as normal activities. She also comments that well-off women, probably and unsurprisingly, had more freedom than other women. No doubt that went for the males too.

The picture of the Good Wife is an attractive one. More Martha than Mary, she is seen as busy about many things. She runs her household like a company director; she understands woman management, rising early, no doubt getting the best bargains in the market, having set the tasks for her servants for the day. She is continuously busy, but the picture is to some extent misleading. Like many women, she thinks best with knitting needles (or in this case distaff or spindle) in hand. She does two things at once – one intellectual, one practical, considering the purchase of a field, while her busy hands are engaged on some other task. She has her cottage industry, selling the girdles she makes to the merchants. To the feminine eye,

her life, though immensely busy was not unrelentingly driven. The ability to do two things at once is one of God's greatest gifts to women. The pleasure of conversation with others, possibly servants, in this case, goes along with the necessity of physical work. It may also be the case that when the Good Wife sees her husband, well-dressed, thanks to her, setting off for the gates to discuss weighty matters with his cronies, she thanks God for the quiet about the house! Yet she loves her husband, who trusts her absolutely, brings her children up to bless her, and is kind to the poor.

What Women Contribute

'Patriarchy' and 'androcentrism' are the two 'boo' words of feminist theology. If patriarchy represents human fatherhood writ large, androcentrism, according to Rosemary Ruether and others, means that men have the monopoly of leadership and therefore can dominate the culture.[16]

While it is undeniable that the books of the Old Testament, like those of the New, were written by men, and that women are less in evidence, their stories form a striking element. Eve, Sara, Rebecca and Rachael, Ruth and Naomi, Esther, Judith, Delilah and the Queen of Sheba do not, for good or ill, bear out her belief that it is normal for women to be silent and not in evidence.[17] In any case, the transmission of culture is a complex matter. It is the women in any culture who have the primacy in bringing up young children and who by their handling of the baby teach that the world is a safe, predictable, comfortable place to be. Where they fail to do this, the child bears a burden of insecurity from its earliest days.[18] This truth, known instinctively through the millennia, was ridiculed by many sociologists and those involved in the theory of child-care during the last forty years or so and it is now being painfully relearned. 'The hand that rocks the cradle rules the world' is a truism that turns the concept of rule on its head.

Even though, in Old Testament times, women were not affirmed as Christianity was to affirm them, the centrality of the family within the Chosen People gave women a status very different from that of the women in the Greek city states. It is difficult to imagine a picture similar to that of the Jewish Good Wife in praise of the upright Roman matron as *materfamilias*, let alone a classical Greek equivalent. For, as Francis Martin comments, to describe the Bible as androcentric is 'to impose modern sensitivities, which have their own bias, on a text that makes sense without such labels ... The Bible should not be treated as part of some sinister, misogynist plot.'[19]

Contemporary thinking has an 'action man' view of achievement. It must be remembered that Our Lord himself wrote no books, was not politically active or influential and chose humble people without learning to carry on his work. He led through service and this has been the way, however imperfect their achievement, of millions of his followers ever since. We have also to include those who have, perhaps, never even heard his name, but whose fidelity to conscience has led them in the right path.

It is not only women who have, for most of history, been excluded from education and influential positions. Even in an educated democracy, most individuals have little opportunity of influencing events in the public sphere. Yet many feminist writers turn such opposites as superiority/inferiority, right/left, light/darkness, active/passive, life/death, reason/feeling into male/female symbolism, as if all men were the chiefs and all women the foot soldiers. The vast sweep of such statements leaves them vulnerable to the judgement of daily life. The female of the species is sometimes more deadly than the male – sometimes more energetic, sometimes more reasonable, sometimes less feeling.

Stories of Creation

Feminist theologians are naturally interested in stories of creation; they ask if they reflect equality of male and

female; and if they reflect a female creator? In her book, *Gaia and God*, Rosemary Ruether considers creation stories from three sources, Babylonian, Greek and Hebrew and measures them by their attitude to women.

Babylonian

The Babylonian story does indeed begin with a mother goddess who gives birth to heaven and earth, to the forces of nature such as water, air and vegetation and then afterwards to the gods and goddesses who resemble human males and females, and who fight over the places of which they are the tutelary guardians. One consort of the mother goddess, unable, like many another father on a Sunday afternoon, to stand the noise of their young, sparks off a generational conflict in which the mother is ultimately killed and her body used to seal off the waters of the sky, while the stars are fashioned on the underside of her body. To achieve these ends, her body is split like a shellfish. This tale does not strike me as an encouraging precedent. Ruether rather primly comments that, although the first societies were matriarchal (and we are not told how the goddess conceived in the first place), the unseemly end of the tale shows how women's power is overturned.

It is not surprising that certain cosmological ideas are common to the Semitic world, such as the solid firmament and the waters above it. But the tone of Genesis is unique, having a nobility and spirituality quite unlike the quaint narratives of polytheism.

Greek

In Plato's *Timaeus*, Rosemary Ruether sees, correctly in my view, a pattern of hierarchy in which women are secondary and inferior, produced by the failure of male souls to control the urges of the body – such souls, Plato intimated, are incarnated in women. This story reveals a certain uneasiness with the corporeal, while consciousness and mental powers are seen both as good and of primary importance.[20]

Hebrew

Sister Madonna Kolbenschlag, piquantly enough, a sister of the Humility of Mary, regrets that the Christian tradition sticks to the story of the creation in Genesis. She feels that it makes patriarchy 'natural'.[21] If one accepts belief in a Creator at all, it must follow that the creator is greater than his creation. At least, his fatherhood is exercised over male and female alike – both in the image of God. This image is, of course, expressed in the spirit, not the body. God the Father is not an old man with a beard, although, as I hope to show later, there are good reasons for using the male pronoun to refer to him. But neither is he a mother goddess.

Male and Female

In Genesis, man is created as male and female and in the image and likeness of God (Gen. 1.27). This is the essential mythic truth that Scripture teaches us. In the second, simpler account of creation (the Yahwist account), we are told that Adam seeks a *vis-à-vis*, and because he does not find one among the animals, God fashions a woman from his rib (Gen. 2.22). There is no hint here of that uneasiness with material things that we find in *Timaeus*, no hint that matter is evil. Edward Holloway quotes the discovery of R. Dyson, S.J. who suggested that the sign we render as 'rib' (Gen. 2.21–23) is derived from an older but related Sumerian script symbol, the sign of the Arum lily, which indicated the male principle of life and generation. That would mean that the 'principle of life and generation' became Eve. If Adam presages Christ, and Eve the Church, then we are presented with a wonderful image of Christ and his Church, almost as 'two in one flesh'.[22] If Eve was taken from Adam's rib, the two of them could be seen as being side by side.[23]

Ruether, however, describes the creation of Eve as a very peculiar story, where God, reversing the usual form of childbirth, acts as midwife to the birth of the female

from the male. She sees this as confirming women's secondary position and says that Christians are so used to this assumption that they do not find the story odd. There is something very literal about her interpretation. As I read it, God's way of bringing Eve into the world emphasizes the closeness of man and woman, the unity of the two, of which Pope John Paul II speaks in his encyclical *The Dignity and Vocation of Women*. Just as the Trinity is God in relation, so man cannot exist without the relationship of his kind. Far from being odd, the story of creation manifests the 'flesh of my flesh, bone of my bone' commitment of one to the other (cf. Gen. 2.23).

The *Catechism* points to a multi-textured interpretation, in which Adam stands for Christ, whose redeeming act 'gives birth' in one sense to the Church, which Eve represents. This is seen as prophetic of the Incarnation, 'decreed before the foundation of the world and independently of the Fall of mankind'.[24] The *Catechism* quotes St Peter Chrysologus, who saw Christ as the 'last' Adam, who had made the first Adam in his own image when he created him, 'that is why he took on himself the role and the name of the first Adam, in order that he might not lose what he had made in his own image'.[25]

However contemporary exegetes may interpret it, Genesis does not reveal Eve's position as servile. She is described as helper or helpmate, but that does not necessarily imply inferiority. A teacher helps a child with the lesson. The psalmist calls God a help and a shield (Ps. 33.20). Manfred Hauke computes that of the nineteen usages of the noun 'help' in the Old Testament, fifteen refer to God![26] We are here looking at the principle of 'unity-in-diversity'. This is the conviction that true unity does not require sameness, but on the contrary presupposes difference: true unity is not based on a levelling of all variation, 'but celebrates and guards that which is unique to each'.[27] Furthermore, the comment in Genesis 2.24, 'This is why a man leaves his father and mother and joins himself to his wife and they become one body' implies equality. One cannot become one body with a slave, still less with an animal.

The Fall of Man

Manfred Hauke observes that in the multiplicity of creation myths which arose in the Near East, the story of Genesis is the only one in which women and men are in relationship.[28] As we have seen, there is a mutuality of giving and receiving. It is only after the Fall that the woman is told by Yahweh that her yearning will be for her husband and he will lord it over her (cf. Gen. 3.16). In *The Dignity and Vocation of Women*, Pope John Paul II characterizes this as indicating the disturbance and loss of stability and fundamental equality that the man and woman possessed in the unity of the two. This is not to imply that men have the right to oppress women, nor yet that it is women's duty to accept it. Men and women are still called, as they were from the beginning, not only to live alongside each other, but to exist mutually, each for the other.[29]

In his *Letter to Women*, John Paul II speaks of the complementarity of womanhood and manhood, not only from the physical and psychological point of view, but also from the ontological (meaning, from their very existence). It is only through the duality of the masculine and feminine that the human finds full realization. At once individual and together, they are enabled to experience their interpersonal and reciprocal relationship as a gift from God, which enriches them and also confers responsibility.[30]

Rosemary Ruether admits that the text of Genesis leaves open the equality of the male and the female but she interprets the use of the masculine pronoun for God as implying the superiority of the male. Sister Madonna Kolbenschlag believes that patriarchy is firmly rooted in Genesis and regrets that another of the available myths was not chosen.[31] She understands the sin of Adam and Eve as sexual because they knew they were naked. She argues that the snake was an image of fertility in the ancient world, associated with women and their power, so that to banish the serpent was to banish woman as goddess and sexual free spirit. This is, of course, pure

speculation, but it reveals a hedonistic viewpoint. Untrammelled sexual activity does not represent maturity. It is very naïve to suppose that a sexual free-for-all would produce a happy and balanced society; nor in such circumstances would it be certain that women would have the power. Kolbenschlag further states that it was Satan's promise that they would be like gods, that led to their condemnation. Eve, according to Kolbenschlag, exercised her female power and authority by taking the forbidden fruit and it was not her disobedience but her autonomous self-affirming act that God condemned. She feels that Eve and her successors were cheated and made inferior. She seems to imply that females would have dominated males, but for the divine judgement on Adam and Eve.

A Feminist Understanding of the Old Testament

Rosemary Ruether, for one, seems to me to be more at home in the Old Testament than in the New. Although she is repelled by what she sees as the making holy of patriarchy, she acknowledges that within the Old Testament itself, there are stories that contradict that position.[32] She sees Yahweh as resembling the common Near-Eastern deities and coming like a mightly king and warrior, dispensing mercy and justice. She recognizes his divinity in his liberation of slaves, and she believes that salvation consists in deliverance from tyranny and the restoration of a free and equal society of peasants. That this represents a comic-opera view does not seem to diminish its charm in her eyes. She presents a very literal interpretation which is only partially sustainable. While it is true that God's care for his people is often expressed in the Old Testament in material terms, that is not surprising when one considers that the Jewish people were still in the throes of learning about salvation. The thrust, however, is always towards the coming of Christ. The exodus story has a further rich dimension in that it provides a foretaste of Christ's liberation of mankind

from the domination of sin. The *Catechism* sees the value of the Old Testament for Christians in that it looks forward to the Redeemer. In that way, too, it is prophetic. Ruether endorses the exodus as a paradigm of liberation in general, liberation from physical and political oppression, which offer the hope of a better life in terms of both material and spiritual goods. She also sees it as a sign of the 'liberation' of women, not only, I would argue, in terms of the basic liberties to be accorded to all human beings, but as a liberation from the limitations of womanhood itself.

God first establishes a personal link with his people by telling them his name (Exod. 3.13–15). He distinguishes himself from other gods through the extended form 'I am who I am'. *The Catholic Commentary on Holy Scripture* gives an alternative form, 'I am because I am', but it prefers the former because it emphasizes the very existence of Almighty God. 'I will be who I will be' is suggested by other commentators. Ruether, among others, uses the form 'I am who I shall become'. Mary Grey similarly sees God as in process of becoming, alongside the world itself.[33] There is a hint that the creator and his creation are somehow marching together. That is not, however, the way in which the Bible presents him. Yahweh is not like the god Wotan, in Wagner's opera cycle *The Ring*, who learns renunciation disguised as the Wanderer as the story unfolds. Ruether regrets that she lacks a name for the God/ess, though she expects that once we have rejected patriarchy, his/her name will appear. She explains the use of this odd term as an analytic sign to point toward that yet unnameable understanding of the divine that would signal 'redemptive experience' for women as well as men.[34]

How does one experience redemption and does it matter anyway in the face of the reality of Christ's saving act? We know that feelings are not important for morality or holiness – though they are great blessings, if they chime with the truths of the faith. They are certainly not to be depended on as an infallible guide. Ruether warms to God's interventions on the side of the downtrodden

and his criticisms of systems of power and those who wield them. She expresses her hope for an age without injustice, but does not wish to base her hopes on Jesus, while Mary Grey says that Jesus seems to bring history, by which I think she means new teachings, to a halt. We can agree with such writers that it is the duty of all of us to fight injustice and cruelty, wherever they come from, even though death challenges all our material concerns and we know that the destiny of each one of us lies in the hands of God.

Notes

1. Chrysostom, *In Gen. Hom.* 2.2, cited in *Catholic Commentary on Holy Scripture* (Nelson, 1953), p. 2.
2. *Catechism of the Catholic Church* (Geoffrey Chapman, 1994), 73.
3. Irenaeus, *Adv. Haer.* 3.20.2, cited in *Catechism*, 53.
4. Pontifical Biblical Commission *On the Interpretation of the Bible*, in *Briefing* 1–19, February 1994; 22–15, March 1994.
5. Biblical Commission, *Interpretation*, Part 1, p. 15.
6. Rosemary Radford Ruether, 'Feminist Interpretation of the Bible, a Method of Correlation', in Letty Russell (ed.), *Feminist Interpretation* (Blackwell, 1995), p. 117.
7. Francis Martin, *The Feminist Question* (T. & T. Clark, 1994), p. 149.
8. Biblical Commission, *Interpretation*, p. 15.
9. Cf. *Catechism*, 61.
10. Elisabeth Schussler Fiorenza, *Discipleship of Equals* (SCM Press, 1993), p. 106.
11. Rosemary Radford Ruether, *Sexism and God-Talk* (SCM Press, 1983), p. 23.
12. John Paul II, *Mulieris Dignitatem*, 10.
13. *Catechism*, 205.
14. Schussler Fiorenza, Discipleship, p. 108.
15. Cf. John Saward, 'Thanks for the Feminine', *Association of Catholic Women*, December 1989.
16. In the Scottish/English tradition we have Robert Burns in the eighteenth century writing in the 'Cottar's Saturday Night',
 The sire turns o'er

With *patriarchal* grace
The big ha' Bible
Ance his father's pride.

17. Daphne Hampson and Rosemary Radford Ruether, 'Is there a place for feminists in the Christian Church?', *New Blackfriars*, January 1987, pp. 7–24.
18. Cf. Richard D. Gross, *Psychology, the Science of Mind and Behaviour* (Hodder & Stoughton, 1992), p. 628.
19. Martin, *Feminist Question*, p. 214.
20. Rosemary Radford Ruether, *Gaia and God* (Crossroads, 1992), pp. 16–24.
21. Madonna Kolbenschlag, quoted by Donna Steichen, *Ungodly Rage* (Ignatius Press, 1991), p. 148.
22. Cf. E. Holloway, *Sexual Order, Holy Order* (Faith Press, 1984), p. 12.
23. Aquinas, *Summa Theologiae*, 1, Q. 92, arts. 2–3.
24. Holloway, *Sexual Order*, p. 12.
25. *Catechism*, 359.
26. Manfred Hauke, *Women in the Priesthood?* (Ignatius Press, 1988), p. 201.
27. Petroc Willey, *Marriage and Sexual Ethics* (Maryvale, 1992), p. 57.
28. Hauke, *Priesthood*, p. 203.
29. John Paul II, *Mulieris Dignitatem*, 10.
30. John Paul II, *Letter to Women*, 1995, section 8, p. 12.
31. In Steichen, *Ungodly Rage*, p. 149.
32. Ruether, *Sexism*, p. 61.
33. For a consideration of Mary Grey's position, see Chapter 3.
34. Cf. Ruether, *Sexism*, pp. 46 and 71.

3

What Do You Think of the Christ?

With this ambiguous earth
His dealings have been told us. These abide
The signal to a maid, the human birth
The lesson and the young man crucified
<div align="right">Alice Meynell[1]</div>

The *Catechism* tells us that the life of Christ is a mystery of redemption. Though our redemption was wrought for us on the cross, this mystery permeates the whole life of Jesus.[2] The human race, whose self-inflicted dysfunction was inherited through the sin of our first parents, was made open to love and thus to God, by God himself, in the person of Jesus. In his love, God the Almighty Father gave us his only Son, so that no one need perish, but could have eternal life, if only they followed him. This following requires both faith and action.

Pope John Paul II points out how Jesus teaches us that the world does not furnish man with what is needed for ultimate happiness. We have another destiny, which God himself offers to us.[3] Thus it is that man's life is not circumscribed by his threescore years and ten. As John Paul II shows, Our Lord echoes the primal affirmation in the book of Genesis: God saw how good it was. God is God-with-us, who joins in our lives and shares our future, seeking to justify himself to mankind.[4]

The *Catechism* speaks of the way in which Christ, in his Incarnation, becomes poor and so enriches us with his poverty; how he submits and thereby makes up for our

<div align="center">35</div>

disobedience. He purified all those he healed and exor-cized, and so took our infirmities and bore our diseases. He *justifies* us in his resurrection.[5]

Comparatively few feminist theologians have written about the life of Christ apart from considering his rela-tionships with women. They are, indeed, a rich subject for study and show very clearly the untrammelled nature of his encounters with them. One who does look at the life of Jesus the man through a wider lens is Rosemary Ruether. When she was a young woman, she had a protracted correspondence with Thomas Merton, the writer and Trappist monk.[6] In one of her letters to Merton, she describes Jesus as a prophet, with a clear vision of the Kingdom of God. She thinks that he believed himself to be the catalyst whom God would use to proclaim his reign. But, because God did not inter-vene, he was 'strung up' as she puts it and his disciples ran away. Ruether asks 'What then to do?' Presumably, she sees herself as speaking for the apostles when she suggests that, rather than admit they were wrong, they pretended that Christ's death was part of the plan. Christ, on the cross, she says, neither admitted that his belief that he was the Messiah was shown to be false, nor instructed his followers to pretend that his death was intended anyway. On the other hand, Ruether may have realized that her question 'What then to do?' was rather muddled. She was not, at the time, writing for publica-tion: the letters were published 25 years later. In any case, she went on to say that what is important, as she sees it, is not what happened, historically, on Calvary, but 'what happens when we encounter this one right here before me'.[7]

Her words seem to imply that she sees Christianity primarily as an ethical system and that her concerns are immediate and social, rather than concerned with death, judgement, heaven and hell. Although the well-being of others, in the deepest sense, is the object of the injunc-tion to 'love our neighbour as ourself', Catholic teaching anchors this intention in the saving death of Christ. It is not clear from this letter whether Ruether believes in

Jesus as the Saviour of mankind, in the sense in which the Church traditionally understands him to be. In this passage, she seems rather to see him as a good, but bewildered man, succumbing to self-doubt.

Rather as she interprets the Old Testament as, largely, a liberation myth, centred on the exodus, and the hope of a land flowing with milk and honey, she is interested in Jesus as one who expressed a radical view of the social vindication of the poor and oppressed, and those who were on the margins of Jewish life, kept down by local landlords, petty rulers and religious authorities. She interprets 'the reign of God' as their liberation.

In an unpublished essay, quoted by Mary Hembrow Snyder in *The Christology of Rosemary Radford Ruether*, she gives a clearer account of the feelings she believes Jesus would have experienced before the crucifixion. She supposes that Jesus thought that God (the Father) would cause his reign to begin by some noticeable act and that he did not have to start the process himself. But the 'final battle' was to be launched from the Mount of Olives and so Jesus went up there, having entered Jerusalem after the manner of King David. According to this view, nothing happened. There was no divine manifestation so Jesus submitted, rather than act without evidence that God wanted him to do so.[8] This speculation leaves out of account all the Gospel evidence that Jesus knew what his hour would entail and that his kingdom was not of this world.

In *To Change the World*, Ruether describes the resurrection as a 'failure', because the Roman occupation continued beyond it. She suggests that Jesus' vision of the world was social and political and that among what she understands as the more 'clearly historical' sayings reported of him, he showed no 'predominant' concern with an afterlife. Elsewhere, however, she describes him as an 'eschat' – presumably someone whose concerns are with the four last things![9]

She does not indicate in this passage which sayings of Jesus she takes as authentic, but the Church's canon includes such sayings of Our Lord as 'Mine is not a

kingdom of this world' (John 18.36); 'the Kingdom of Heaven is theirs' (Matt. 5.10), in the context of those who suffer persecution in the cause of right; 'For I tell you, if your virtue goes no deeper than that of the scribes and the Pharisees, you will never get into the kingdom of heaven' (Matt. 5.20). There are other instances in which Jesus implicitly distinguishes between this world and another world, which is his Kingdom – not to mention his throw-away line 'Give to Caesar the things that are Caesar's and to God the things that are God's' (Matt. 22.21 and Mark 12.17).

Ruether also quotes Oscar Cullmann, who described Jesus' mission as concerned with the transcendent, demanding that his disciples maintain an inner peace, which would enable them to put up with society as it was and behave considerately to others. This was such an individualistic view that Cullmann questions – and Ruether appears to endorse his view – whether he could ever be regarded as a serious contender for the role of Messiah in the understanding of the Jews of that time.[10] It was just this disparity between the expectations of the Jewish establishment and the reality of Jesus that aroused their hostility. It was the will of the Father that the Messiah came as he did. Ruether herself, seems to endorse the view that Jesus does not fit the warrior-king image of the Messiah. But she also seems not to accept him as the Christian Redeemer, either. In an unpublished MS, quoted by Snyder, she emphatically says that 'The Messiah is *never* associated with the eschatological redemption'. The coming of the Messiah, she believes, was to produce such a change in people's lives that it was undeniable. But how this change was to be achieved, she does not say. Thus she believes that Jesus is just a sketch of all human beings who try to improve the world. For her, 'Jesus is not yet the Christ'.[11]

Redemption

In *The Everlasting Man*, G. K. Chesterton wrote 'It is true

and even tautological to say that the cross is the crux of the whole matter.'[12] If the cross is the crux, the result of Christ's sacrificial death is our salvation, achieved once and for all by Our Lord. He gave his life as a ransom for all men.

How do we know we needed salvation? The Venerable John Henry Newman in his *Apologia Pro Vita Sua* writes:

> Did I see a boy of good make and mind, with the tokens upon him of a refined nature, cast upon the world without provision, unable to say whence he came, his birth-place or his family connexions, I should conclude that there was some mystery connected with his history, and that he was one, of whom, from one cause or another, his parents were ashamed ... And so I argue about the world; *if* there be a God, *since* there is a God, the human race is implicated in some terrible aboriginal calamity.[13]

There is a mystery here. We know that the coming of Christ heralded the second chance for mankind. Christ, in his own person, took on the guilt of our sins. That Christ redeemed each member of the human race is both central to our belief and the foundation of our faith.

Why is our life so important to us? From where does our instinct for self-preservation derive? Why do we see self-slaughter as the ultimate dysfunction? Why do we feel such compassion for someone who has lost the will to live? Even if death wins in the end, we like to think of someone fighting 'bravely' against cancer or some other affliction. That life is good has to be the basis on which we live each ordinary day. Each of us knows that an individual life, as an observable entity, is finite, moving inexorably to its end. We can disguise this fact to ourselves, with a multiplicity of activities but the stark fact remains. Some people without faith, find comfort in believing that they are part of a chain of life, which stretches endlessly ahead of the human race. Others look to their achievements to bring them some form of immortality.

The Jews first understood survival as a corporate

matter, involving the chosen people as a whole, each generation validated by the next. Under God's tuition, they came to distinguish the importance of the individual. If death is the end of each person, it mocks our endeavours, gives the lie to love, to our sense of beauty, and our hope for the future. In the depths of our being, we need to believe in a loving God who longs for us to come to him, in our human weakness. Only in this way is 'The hope that is in us' fulfilled (1 Pet. 3.15).

Belief, however, on its own, is inadequate; We are able to take responsibility for our actions, and are often aware of the necessity to do so. Our lives have moral value and are open to right and wrong. Through our free will we are able to choose good or evil in many and various areas of our life, although our bias towards evil is always apparent. We are all tainted by that 'aboriginal calamity' when our first parents defied their loving Creator. That disobedience, coming down through the generations, is endemic to man.

In his letter *The Redeemer of Man*, John Paul II writes 'The world ... when sin entered was "subject to futility"' and again, 'The Redeemer of the World! In him has been revealed in a new and wonderful way, the fundamental truth concerning creation to which the Book of Genesis gives witness when it repeats several times "God saw that it was good".'[14]

God so loved the world that he sent his Son to live a life like ours (though without sin), to share the suffering of all humanity from its beginning, to die a criminal's death in unimaginable pain and through his death and resurrection to conquer sin once and for all. The mystery inherent in all this cannot be unravelled. As Newman writes 'Yet how his death expiated our sins and what satisfaction it was to God's justice are surely subjects quite above us ... it is an event ever mysterious on account of its necessity while it is fearful from the hatred of sin implied in it, and most transporting and elevating from its display of God's love for man.'[15]

Redeeming the Dream

For Mary Grey, in *Redeeming the Dream*, the word 'redemption' is a reminder of many negatives – suffering, sacrifice, guilt and self-negation – all pointers to the lack of the positive in Jesus' position on the cross.[16] She questions whether such a 'metaphor' is suitable for our contemporaries, especially for women. Feminism, she indicates, is dedicated to removing the language of domination and suppression, which she associates with patriarchy.

She begins her book, not by a meditation on, or even a consideration of, the theological concept of redemption, but by listing many, ancillary definitions of the word in *Webster's Dictionary*. She lists 'recover from a state of submersion, reclaim, liberate, fulfil and extricate from futility and meaninglessness'. These nuanced readings do not subtract from the main interpretation, which is 'to buy back, to make payment, to regain or recover' (*Shorter Oxford Dictionary*). It is, indeed, Christ who gives meaning to our lives. She believes that the language of religion should be the fruit of personal experience – otherwise, she says, 'politicans' take it over and people turn to religious experiences outside the Church.

Redemption has a special place in Christian teaching, but Mary Grey does not mention God in her initial two pages and she has only two references to Christ. She speaks of the 'negativity' of the cross and secondly of the creative, liberating vision of Jesus. She begins by speaking of the suffering of women in the Church, who are denied ordination to the priesthood and participation in decision making. One does not wish to take lightly women's real sorrows, but as there has never been the least likelihood that women would be ordained in the Catholic church, every woman would have grown up with the knowledge that the priesthood is reserved for men. The vast majority of women are more worried, I believe, by sickness, distress, loneliness, and loss of family – to mention only a few of the calamities that come to us all. Even in our affluent society and even people of strong

religious faith are not spared anxieties which are often acute. However, in my experience, a sense of loss at being unable to be a priest is limited to very few. Perhaps it is not surprising that she follows this statement with the admission that we can feel burnt out by the suffering across the globe and places feminist theology next to the liberation model. This rather dates the book, because, while the Church's fundamental option for the poor' remains, as it must, the use of religion as a descant on Marxist economics has rather faded. Not for the first time in the Church's long history, a headlong enthusiasm has had to be checked in favour of a more considered approach. Like many feminist writers, she looks long-ingly at decision-making in the Church and yearns to join in, but does not specify whether it is the doctrinal or administrative decisions she has her eye on.

Mary Grey says that she sees creation and redemption as a unified process, and that if we see the human race as a *massa damnata*, we undervalue the fact that it is made in the image and likeness of God, and are forced to see redemption as coming totally from the outside. That makes us human beings the passive recipients of Christ's redemption. Of course, that has never been the Church's view; it more nearly resembles the Protestant belief that faith alone will save us. Nevertheless, we cannot redeem ourselves, and without Christ no amount of good works or self-understanding would be enough. She quotes Matthew Fox, at the time she was writing, still a Dominican friar, who sees redemption-based theology as having put down the body and called the repression holy.

The very ambiguous phrase 'subjugated knowledge', coined by the philosopher Michel Foucault is endorsed by her and she believes that we need to uncover ways of knowing which were suppressed by a triumphalist frame-work. This would appear to be a variation on the theme of personal experience as the foundation stone of belief, which nearly all feminist theologians express. It would lead to an entirely individualistic understanding of the holy. To counter this, Rosemary Ruether, for one, main-

tains that women's experience is everywhere essentially the same – something which is manifestly untrue.

'Protest theology' or 'political theology' are, Mary Grey maintains, essential to Christianity, in order to bring in those on the margins of society, women among them. Indeed, that is to fulfil the second of Christ's great commandments, to love our neighbour as ourself. The Church has, in fact, always understood and sought to relieve the sufferings of mankind. To do this in terms of political action requires great discretion.

Mary Grey's disquiet at the traditional understanding of 'redemption' lies in her belief that it reinforces the idea that women are inferior. She instances the unfairness of the way in which women are branded as 'fallen' because of their sins. May this not be because the Church has higher expectations of women than of men? Not that the Church ever said that men could be fornicators and remain in God's friendship. Yet redemption came through one man, who was both God and man, for men and women alike.

In an odd connection, she links the – often entirely unjustified – feelings of culpability that battered women have, with the cross – she says it is as if these women felt that they deserved to be crucified. Hence, she claims, that women in California, who were shown a sculpture of a crucified woman, which the sculptor, Edwina Sandys, dares to call the 'Christa', identified with the subject, seeing themselves as suffering and unable to give birth to 'creativity'. She hastens to add that it was not just Californian women who reacted in this way.

What Mary Grey and other feminist theologians cannot stomach, it appears, is the demand of self-sacrifice, which Christ makes of every person, female and male alike. We are enjoined to take up our cross daily with him. She does, however distance herself from the remark of Mary Daly that the Christian cross is an instrument of torture *for women* and a divine sanction for child abuse. She also rejects Reinhold Niebuhr's interpretation of original sin, as one of pride. She sees the original sin of women as lack of pride and quotes the author of the *Women's Bible* as

saying that self-development is better than self-sacrifice. How different from St Paul, who told the Galatians that the only thing he could boast about was the cross of Christ!

The Idea of Sacrifice

John Henry Newman wrote to a friend soon after his reception into the Catholic Church, 'Catholicism is a deep matter. You cannot take it in a tea cup.' There can be no deeper matter in Christianity than that of Christ's sacrifice of himself on Calvary. It is not to be understood; we can only approach it with faith. Faith has to come first. We seek for Christ and having found him we have to believe, whether we understand or not. We cannot sit in judgement on God; we have to humble ourselves and accept that what he says is true. We know what he says through sacred Scripture, and the integrity of Scripture is guaranteed, as Christ promised, in the teaching of the Church.

We are not to think of this event as the demands of a cruel father. God the Father and God the Son are one. They both wanted to be with man in his severest suffering, since suffering is part of the human condition in its fallen state. The justice of the Father is the justice of the Son: the love of the Father is the love of the Son. The suffering of the Father and that of the Son are the same. By what other means could man have become part of Christ, when he had rejected God and chosen himself? Our easy acceptance of sin is put to shame by this understanding.

Whether we believe, with Duns Scotus, that it was intended from all eternity that Christ was to share our human life, and our human suffering, or whether we believe with Aquinas that human sin was the catalyst for the Incarnation, does not finally matter. The fact of sin is self-evident; more than that we cannot be sure. What we cannot do is sit in judgement on God.

Relationship

For Mary Grey, relationship is the core concept and she quotes Matthew Fox, who describes divine creative energy as the basic stuff of the universe. Strangely, she does not here speak of the concept of God-in-relation in the Trinity, which, impossible as it is to understand completely, nevertheless provides the starting point for creation and all that follows. The relationship that she considers is that of God and mankind and she sees that women are pre-eminent in revealing this world of inter-relatedness. That is surely self-evident. Small boys play at war and chasing, but little girls play at fantasy games, in which people interact – mothers and fathers, for instance. Grey considers that this characteristic is not innate, however, but derives from the fact that women have been left out of the competitive ethic. Males acquire aggression in our society, according to Grey, because they are removed at a young age from female influence. In what I feel is a weak instance, she cites English boys of seven being sent off to boarding prep-schools and students for the priesthood starting at Junior seminary at eleven. That can account only for very few males! In most European (and other) cultures boys have always been brought up in their families.

There is a certain ambivalence in her assessment of women's particular gift for relationships. It is not wholly clear whether she thinks women have lost out by being removed from the ethos of competition, or whether males are denied something of value by being exposed to it. While valuing the relational above all other concepts, she is unhappy that women are often stuck in 'relational' jobs, like nursing. How, she asks, can they 'transcend' the boring, relational routine and develop themselves? Perhaps we are to conclude that relationality can be too much of a good thing.

Is there some way of betterment for the human race, without the 'negativity' of Christ's suffering on the cross, which she feels makes women feel even more guilty than they have been taught to feel by an oppressive society?

The answer for her lies in the 'process theology' of A. N. Whitehead (1861–1947). One of the great apostles of self-help, along with Samuel Smiles, was a man called Emile Coué, whose catch phrase or mantra was the cry 'Every day, in every way, I am becoming better and better'. A theology, not wholly unlike Coué's 'philosophy' comes to the rescue of Mary Grey here. She describes how process theology postulates the notion of God and human beings co-operating in the effort to heal and to bring together everything in the universe; both God and man becoming better and better. With Whitehead, she believes in a system of divine and human 'becoming' though she criticizes those who do not anchor this belief firmly in political and social structures. God and man are seen as developing alongside each other. God is thereby neither almighty, nor immutable.

Monika Hellwig also comments on the ideas of Whitehead and those of Teilhard de Chardin both of whom saw Christian experience, including Christology, as an evolutionary one. Teilhard postulated that Christ would become the 'omega' point of human evolution, resulting in a universal community of human beings. Most theologians, according to Hellwig, rejected these ideas, either because it renders the cross redundant, or because they were seen as a form of triumphalism – something that would happen without personal effort in the course of history, once a few difficulties were ironed out. Hellwig describes Whitehead's as still (1983) a consistent theology.[17] Consistent, no doubt: Christian, very doubtfully.

The Trinity is indeed God-in-relation and as Creator and Redeemer, God is in relation with the whole of humanity. Christianity, however, cannot endorse a picture of God developing alongside his people, because there is no room for improvement in God. Though, God knows, *we* have room for improvement, our salvation was achieved once and for all on Calvary. How we accept this greatest of all gifts, is up to each one of us.

It seems extraordinary that anyone living at the end of this most brutal of centuries can claim that mankind is

'improving'. Some people, in some places may be more considerate, more affluent and have a more pleasant life to live, but it takes some optimism to look back on the horrors of Nazi and Marxist oppressions, on wars, greater or smaller, still afflicting, even in their aftermath, thousands upon thousands of people and see mankind as essentially better than it was in earlier centuries. In the rich 'civilized' world itself, millions of pre-born human beings are slaughtered with the approbation and often encouragement of governments – the innocent fruit of shallow and trivialized sex.

Under the heading, 'Re-imaging the Life-Praxis of Jesus as Atonement', Mary Grey writes that the symbol of Christ the Redeemer must not be seen as one among many images drawn from women's experience. This means, as she admits, abandoning a Christocentric faith on the flimsy grounds that, with the centre occupied by Christ, other people, women, Jews and ethnic minorities are *not* at the centre. She jokes that Christ as saviour has a tendency to cause history to stop.[18] It now becomes clear that when Mary Grey uses the word 'redeem' she merely means 'ameliorate' and what she wants ameliorated is the social position of women. It seems a meagre use of religion, for women have immortal souls too.

The Embarrassment of the Resurrection

If the crucifixion is seen as an unhappy accident, the resurrection is an embarrassment. Rosemary Ruether's writing, for example, is not in general remarkable for brevity or elipsis, but on the subject of the resurrection she is brief. In *Sexism and God-Talk*, she speaks of the 'shock of the crucifixion' – describing it as a denouement the apostles had not expected. After initially drifting off, they came together, she suggests, because of their collective experience of the resurrected Christ. She refers, obliquely, to the 'resurrection experience'.[19] This curious phrase, not uncommon, unfortunately, in contemporary biblical criticism, serves to hint at a distance between the writer and the event. It is also

irresistibly reminiscent of publicity for entertainments – 'the Disneyworld experience', the 'millennium experience', 'experience virtual reality!' It reveals Ruether's dilemma, faced with the risen Christ.

Other moments in the life of Jesus can be accommodated. A baby is born – an ordinary event which has attracted fantastic stories to embellish it. An execution takes place – alas! also an everyday occurrence, somewhere in the world. But a dead man, risen again, is unique and the claim that the resurrection happened has to be confronted head on. Ruether's biographer asks in what measure can one understand the apostles' faith in the reality of that event.[20]

We all know from observation that human beings are likely to believe what they want to believe, but most religious illusions fail the Gamaliel test (Acts 5) and fade away. Gamaliel, a cautious lawyer, counselled the elders of Israel to give the apostles the benefit of the doubt, after the Ascension, saying that if they were not of God, their witness would fade away. Ruether finds no explanation for the apostles' faith and simply quotes the Jewish historian Josephus writing in the first century AD, who concluded that 'Those who first loved him did not desist and so until now the race of Christians has not died out'. In debate, Ruether was pressured into a more defined position.

Two Feminists in Debate

In 1987, the theological journal, *New Blackfriars*, recorded an interesting debate between Daphne Hampson, a former Anglican Christian and Rosemary Ruether (a Catholic).[21] Hampson argued that Christianity is essentially 'sexist' (that is oppressive of women) and, at the same time, rooted in history. For these reasons, she said, she did not believe in it. Ruether began her reply with a rather muddled excursus, insisting that our primary duty is to ourselves, and that we need to be supported by a community, if we are to function as creative beings. She added that women's

sense of self-sacrificial duty often led them to deny themselves. She then countered Hampson's assertion by insisting that Christianity is not historical but a matter of faith in the ultimate end of human beings. This view contrasts sharply with the one she expressed in *To Change the World* (1981), where she describes Jesus' vision as social and political.[22] In this debate, she went on to say that the resurrection is not a literal fact, something that really happened, which one could have witnessed, had one happened to be in Jersualem on that day, but a metaphorical truth. She then alleged that theologians who use 'ambiguous' language and say that 'Jesus rose from the dead' are doing so because the gap between theologically educated and uneducated Christians is otherwise impossible to eliminate.

This patronizing statement, which excludes from theological 'education' most of the saints (indeed, one may suppose, *all* the saints) is not endorsed by the *Catechism*, which is firm that 'the resurrection was an historical event' and further maintains that it stands at the heart of the mystery, both surpassing and transcending history.[23] Ruether is limiting herself unduly. The resurrection, though not metaphorical, is certainly *mythic*, which means we can explore and unpack level upon level of meaning in it: an inexhaustible study, arising from an historical event. Hampson's perception of the Christianity which she rejects, is accurate in as far as she recognizes that the faith is rooted in the real birth, death and resurrection of Christ. Ruether's wavering, political *aspirant*, denied a divine nature, is an unlikely figure to retain the allegiance of his followers – a cascade of millions down through history – an allegiance that ended for many in this world, in death, while many more have suffered hatred or deprivation.

Notional and Real Assent

John Henry Newman, in *A Grammar of Assent*, makes a clear distinction between notional assent and real assent,

which is pertinent here. He says that the 'concrete' impresses the mind in a way that the 'abstract' cannot. He understood that the more powerful the object, the stronger the pull of its attraction.[24] We give notional assent to an idea; we give real assent to concrete facts. It was, surely, 'real assent' that the apostles gave to the fact of the resurrection. Their very surprise in the days after Easter emphasizes the solid nature of the acceptance that grew on them. A merely metaphorical resurrection would have provoked a very different and much less solid response. There was nothing airy-fairy or wishy-washy about Christ's rising from the dead. His body was glorified, but it was still a body.

Christians are Easter people. Newman quotes Pascal:

> Here is a religion contrary to our nature, which establishes itself in men's minds with so much mildness, as to use no external force; with so much energy that no torture could silence its martyrs and confessors.[25]

How the Early Church Saw Christ

In the Prologue to his Gospel, John states with great clarity that 'The Word was made flesh, he lived among us' (Jn 1.14). He insists on the fact of Jesus' physical existence as historical. Similarly, on the day of Pentecost, Peter's address to the people shows forth the knowledge that he and the other disciples had of Jesus as a real person '... whose body did not experience corruption. God raised this man Jesus to life' (Acts 1.31–32). One of the earliest of the post-apostolic writers, Ignatius of Antioch, is similarly insistent on the reality of Christ's life, death and resurrection. To the Trallians, he writes that Jesus was *really* born, was *really* crucified, *really* rose from the dead. He goes on to say that if the sufferings of Jesus were not real then 'Why am I now a prisoner? Why am I now praying for a combat with the lions? For in that case, I am giving my life away for nothing.'[26]

Jesus was seen from the first as a man with all the human characteristics, not as some metaphor or paradigm. Monika Hellwig, refers to the 'private and shared experience', which began with the Ascension of the Lord and continued in the joy of Pentecost: she calls these events 'stories'.[27] She seems to qualify or even negate her argument by saying that the moment at which one takes responsibility for one's faith, after introspective thought and the observation of others, is more important than expressions of dogma. These stories, she believes, show what people admired in Jesus, whether or not the particular tales are chronicles or actual events or merely constructs and quotes 'modern scholars' as discerning a difference between the Jesus of history and the Jesus of faith. As the witty Mgr Ronald Knox so rightly said, 'Any stigma will do to beat a dogma.'

Christ, Man of his Time?

Karen Armstrong is an English writer, best known for her writings about her years as a sister in religion. In her book *The End of Silence* she appears rather to play up the difficulties of assessing the Gospels. She dates them long after the events they describe and remarks that the preoccupations and experiences of the early Church colour the narratives. Her book is making a case for the ordination of women to the priesthood, so it is not surprising that she emphasizes that Jesus has been seen in different lights at different times. She says he has been understood to be wholly human and wholly divine; as a nationalist or as an anarchist, a Pharisee or as the founder of a Jewish sect. She claims that if the Gospels had been more specific and less ambiguous, they would have been too narrow to inspire all the generations since they were written. She accepts that the Gospels show an underlying consistency, but believes that people have been selective in their interpretation of them.[28]

There is a certain truth in this. The nineteenth-century prayer to 'Gentle Jesus, meek and mild' contrasts

strongly, for instance, with the Old English poem *The Dream of the Rood*, in which the tree of the Cross speaks:

> There I saw the young hero strip he that was God Almighty[29]
> Strong and brave he took his stand on the tall gallows,
> High of heart when he desired to save mankind.
> ... I trembled when he embraced me with his arms.

Christ is rarely pictured as a hero in current religious teaching. Yet, we need heroes. 'Role models' are not enough. I think this is particularly true of young boys. Christ's death for our ransom is heroic beyond any other exemplar. The agony in the garden recounts how he overcame human fear. Should this aspect of his life not be presented in religious education?

One aspect or another of Christian truth has been emphasized at one time or another in the Church's history; nevertheless, the beliefs of the Church about Christ have been secure and unwavering since the Council of Nicaea rejected the argument that the Son of God was inferior to the Father, and since Athanasius, standing, as was said, against the world, subsequently defeated those bishops and others who held that Jesus was not divine.

The Arians were influenced by the rationalism of their day, but Athanasius rested his case on the Christian doctrine of redemption – that the Redeemer of the world had to be divine. Christ was indeed divine and of one substance with the Father, but at the same time distinct from him. These doctrines were subject both to scrutiny and controversy and, allied to these difficulties, was the necessity of understanding the nature of Christ's humanity – was it like that of all men or was it a semblance – God in human disguise? By the end of the Council of Chalcedon in AD 481, Pope Leo's teaching that Christ had two natures and was truly divine and truly human was accepted by the Church as a whole – though heretical views still hung on, here and there, notably in the east.

Armstrong, by homing in on different emphases or recognized heresies, appears to suggest that one view of

Christ is as good as another, with the sub-text that, as we know little about the foundations of the Church, fundamental changes to Christianity, like the ordination of women to the priesthood, can be accommodated with little difficulty. She sees Jesus as very much in the tradition of the Judaism of his time. The Gospel accounts, however, make it plain where and how he departed on his own initiative from Jewish laws and customs. He underlined the fact that interior purity was more important than ritual hand-washing, that paying tithes of dill and mint and cumin was no excuse for neglecting justice and mercy. The injunctions on Sabbath rest were not to deny healing to someone in need of it. Indeed, the Jewish establishment gave him up for crucifixion on the grounds of his blasphemous restating of divine law.

Mary Grey looks at the question of redemption without considering the incarnate life of Jesus at all deeply. She describes him in abstract terms as being linked to God in relational energy and as having the desire to draw his friends into this relationship.[30] Rosemary Ruether, as we have seen, thinks that the Messiah would have changed everything in terms of politics and society. Jesus, therefore, could not be the Messiah. She concludes that Jesus has been made into a symbol of ideal humanity, or even just a paradigm of those human beings who try to make the world a better place. For her, Jesus is not the Christ – yet – though how he is to become the Christ is unexplained.[31]

The *Catechism of the Catholic Church* describes God's Spirit as preparing for the coming of the Saviour. The promise made to Abraham inaugurates the economy of salvation, at the culmination of which the Son himself will assume the 'image' of God in man, and 'restore it in the Father's likeness, by giving it again its glory', after its disfigurement by sin and death.[32] What we think of Christ and how we respond to the Gospels define our Christian faith. We have to open ourselves in humility to Jesus, himself.

Jesus and the Women of the Gospels

Humanly speaking, Jesus first learned how to be a human being, that is, learned proper human behaviour, from a woman, his mother. Later, Joseph, a real father, through his adoption of Jesus, added the lessons that a father gives. As Mary was sinless, she was the perfect mother, entirely loving, without resentment or selfishness, full of joy and wonder at the child 'growing in grace and wisdom', who was both God and man.

It says much for the veracity of the Gospels that they do not show the infant Jesus performing miracles, as some of the Gnostic 'gospels' do. He was a true baby, learning to walk and talk in the human way. His babyhood was not easy; born far from home, an outhouse stable giving his mother at least a measure of privacy, which the open dormitory of a common inn would not have afforded her; then a flight into exile at night, fleeing the murderous troops of Herod, and arriving without friends or family in a foreign land. He must have been distressed, exhausted and crying. Mary would have forgotten her own tiredness in comforting him.

Humanly speaking again, his perfect open and trusting relationship with his mother can be seen as laying the foundation for the amazing freedom and openness of his relations with all the women who appear in the Gospels. He touched the hand of Peter's mother-in-law and she got up, restored to health (Matt. 8.15). He took the hand of the dead girl, the daughter of Jairus the synagogue official, saying gently in his native Aramaic *Talitha cumi* ('Little girl, get up') (Mark 5.41). If, as many commentators believe, Mark got his material from Peter, those are the very words Jesus used and that Peter, as one of the witnesses of this event, actually heard.

However, it was the woman with the haemorrhage who, herself, touched Jesus. He said that he felt the power going out of him. These physical contacts emphasize the incarnation. The woman in question must have been desperate to risk public humiliation in seeking a

cure for her sickness, which, in Jewish law, rendered her untouchable. Jesus said it was her faith that had restored her – as if, by her belief in his power, she drew it to herself.

When the pagan Syro-Phoenician woman followed Jesus, making a nuisance of herself, begging him to free her daughter from an evil spirit, he was almost harsh with her, insisting that his mission was to the Jewish people alone – or was he teasing her? She gives us a lesson in persistence, which Jesus endorses on a number of occasions; telling the parable of the householder, who continued to knock at his neighbour's door, because he needed an extra loaf of bread, for example. He told this tiresome woman that the dogs were not given the children's food; she told him that the dogs eat the crumbs when they fall on the floor (Matt. 15.21–28; Mark 7.24–30). Jesus responded to her quick wit. Her daughter was cured at once.

Martha and Mary

We know that Jesus loved the company of his friend Lazarus and his two sisters and liked to visit them in Bethany. St Luke states that the house there belonged to Martha and we learn that she was inclined to agitation, not to say fussiness. Most women will empathize with her. Nothing is worse for a hostess than having a member of the family sitting idly by, apparently contemplating higher things while she is feeling harassed, preparing a meal. Jesus, when appealed to, did not join in the family quarrel, but gently explained that there are things more important than setting the table. Martha could have reacted to his words with even greater annoyance, but she must have accepted his lesson in patience and forbearance. She certainly did not bear a grudge against him, because when her brother fell ill, she asked him to come at once.

The portraits of Martha and Mary are both vividly drawn by St Luke; each reacts characteristically each time

we meet them. When Martha heard that Jesus was at last approaching (too late, she thought; her brother had died) she went out to meet him, while Mary stayed in the house. Martha's forthright reproach to Jesus was almost hostile. 'If you had been here, my brother would not have died'. (Jesus had delayed in setting out.)

Like the Syro-Phoenician woman, Martha had her wits about her and when Jesus said 'your brother will be raised', she countered that she knew he would rise at the last day, but that she wanted him back then and there. Yet, when Jesus, in an act of wonderful generosity, told her that he himself was the resurrection and the life, this bossy woman, busy about many things, answered him with the perfect and humble response: 'I know that you are the Christ, the Son of God, the one who is to come into the world.' Mary, equally characteristically, fell at the feet of Jesus with tumultuous sobs and Jesus cried with her, before he brought her brother, so dramatically, back to life (John 11).

Six days before the passover, John tells us (John 12.1ff.), at a dinner in Bethany, Mary poured precious ointment over the feet of Jesus, drying them with her hair. Jesus said she had done it for his burial. A similar story is told of a prostitute, who also anointed the feet of Jesus with precious ointment, in a gesture of humility and contrition. Jesus gently rebuked Simon, his host, for his careless reception of him as his guest – no washing of the feet or special welcome. He praised the woman for what she did, saying that she would be remembered for her contrite act and that her many sins would be forgiven (Luke 7.36–5). The encounter with the Samaritan woman, recounted by John, is as heart-warming and remarkable as any of the exchanges reported in the Gospels.

The Samaritan Woman and Mary Magdalen

We see a village square in Samaria, with the village well in it. The place is empty in the noonday heat, and Jesus is

wearily sitting there, while his disciples go to buy food. A woman approaches the well and Jesus asks her for a drink. She is amazed, since Jews do not associate with Samaritans, nor do respectable men approach women. With an almost yearning frankness, Jesus speaks of the 'living water' that he can give her, quenching thirst for ever. She is interested, but unable to understand what he is saying in spiritual terms. She is brought up short, however, when he speaks of her personal life, her five husbands and current lover! 'I see you are a prophet', she says and goes on to ask him about the differences in belief between Jews and Samaritans and how and where her people should worship. She awaits the Messiah too, though perhaps without too much sense of urgency! But Jesus plainly says to her 'I am he' (John 4.36).

The resurrection of that Messiah is first witnessed by a woman. Mary Magdalene went with the other women to the tomb, bringing spices to lay on the body of Jesus. These women did not run away and did not allow themselves to be overwhelmed by their sadness. They went to do what was necessary for the rites of the dead. When she saw the risen Jesus, Mary Magdalene was sent to Peter and the other disciples to tell them of these astounding events. She was sent and an apostle is one who is sent. She was sent, however, not to teach the whole world, but to tell the apostles.

Karen Armstrong remarks with justice that the emphasis on service, in the teaching of Christ, was one that the apostles found particularly hard to accept. She says that the women mentioned in Luke 8.2–3, who served him and provided for him out of their own means, were closer to his teaching than the apostles, who were concerned about status and reward.[33] Service (*diakonia*) lies at the heart of Catholic teaching – even the Pope is the 'servant of the servants of God.' Service is not the same as slavery: it requires an intention not an imposition. But the opposite of service is the 'I will not serve' of Satan.

The warmth and beauty of the encounters between Jesus and women can be seen to provide another assurance of God's love for women and men alike.

Redemption as Self-Affirmation

According to Mary Grey, the idea of redemption 'encapsulates the yearning' of the whole universe to be made whole. Apparently rejecting the idea that man's wilfulness shattered the life of Paradise, she endorses the way process theology sees God and man as working together on their redemptive task. There is, of course, a certain truth in this. Our redemption is Christ's work, but our co-operation with it is necessary. She does not mention the 'happy fault' as the early Christian hymn, the *Exultet*, calls it, the 'necessary sin of Adam, that brought so great a Redeemer'. She says that women must be prepared to face up to 'aloneness' and each woman must become a 'self'. This she allies with 'goddess spirituality' and she thinks it has much to teach Christianity. She observes that many women who have had a Christian upbringing find something in the goddess movement, whereas in Christianity they feel rejected. A critic would suggest that this was making God in woman's image. Self-affirmation can never be total.

Notes

1. Alice Meynell, 'Christ in the universe', *Collected Poems*, (Burns, Oates & Washbourne, 1940), p. 126.
2. *Catechism of the Catholic Church* (Geoffrey Chapman, 1994), 517.
3. Cf. John Paul II, *Crossing the Threshold of Hope* (Jonathan Cape, London, 1994), pp. 55–6.
4. John Paul II, *Crossing*, pp. 55–6, 62.
5. *Catechism*, 517.
6. Published in Rosemary Radford Ruether, *At Home in the World* (Orbis, 1995).
7. Ruether, *At Home*, p. 25.
8. Rosemary Radford Ruether, unpublished, untitled essay in M. H. Snyder, *The Christology of Rosemary Radford Ruether* (Twenty Third Publications, 1988), p. 38.
9. Rosemary Radford Ruether, *To Change the World: Christianity and Cultural Criticism* (SCM Press, 1981), p. 14.
10. Ruether, *Change*, p. 11.
11. See Snyder, *Christology*, pp. 46–7.

12. G. K. Chesterton, *The Everlasting Man* (Burns and Oates, 1973), p. 135.
13. J. H. Newman, *Apologia Pro Vita Sua* (Longmans, Green, 1909), p. 268.
14. John Paul II, *Redemptor Hominis* (Catholic Truth Society, 1979), p. 22.
15. J. H. Newman, *Essays, Critical and Historical* in C. S. Dessain (ed.), *The Mind of Cardinal Newman* (Catholic Truth Society, 1974).
16. References to the work of Mary Grey on pages 41–46 of the text refer to *Redeeming the Dream* (SPCK, 1989), pp. 1–34.
17. Monica Hellwig, *The Compassion of God* (Dominican Publications, 1983), p. 50.
18. Grey, *Dream*, p. 150.
19. Ruether, *Sexism*, p. 122.
20. Cf. Snyder, *Christology*, p. 38.
21. Daphne Hampson and Rosemary Radford Ruether, 'Is there a place for feminists in the Christian Church?', *New Blackfriars*, January 1987, pp. 7–24.
22. Ruether, *Change*, p. 14.
23. Cf. *Catechism*, 647. The 'them' and 'us' distinction has been made over and over again in Christianity. The docetists in the early Church made a distinction between the simple and those in the know (the gnostics). According to them, everything that was incarnated with Christ, everything to do with his physical life as a man, was of concern only to the simple. The theologically 'educated' did not believe that Christ had a real body at all. He was only pretending to be human.
24. J. H. Newman, *Grammar of Assent* (Notre Dame, 1979), p. 49.
25. Newman, *Grammar*, p. 244.
26. Ignatius, 'To the Trallians', *Early Christian Writings* (Penguin, 1968), p. 80.
27. Hellwig, *Compassion*, p. 59.
28. Karen Armstrong, *The End of Silence* (Fourth Estate, 1993), p. 42.
29. *The Dream of the Rood*, author's translation, original text ed. Henry Sweet, in C. T. Owens (ed.), *An Anglo-Saxon Reader* (Oxford University Press, 1948), p. 14.
30. Grey, *Dream*, p. 97.
31. Snyder, *Christology*, pp. 30–47.
32. *Catechism*, 705.
33. Armstrong, *The End of Silence*, p. 52.

4

The Blessed Virgin Mary
in Feminist Theology

To Mary, Queen, the praise be given.
Samuel Taylor Coleridge

Feminists before Mary

When they confront the Church's teaching about Mary,
feminist theologians are faced with a paradox. In a
Church which, without exception, they berate as essen-
tially 'sexist', by which they mean one that discriminates
against women in its structures, its acceptance of a male
Redeemer and its use of male imagery to describe the
Godhead, the Blessed Virgin Mary has such an important
place. Why is it that a Church, allegedly so dismissive of
women pays Mary such honour and acknowledges her as
the highest being in all creation?

Rosemary Ruether sees her as the wrong sort of
woman – with little to say to the women of today. Mary
Daly describes her as virtually catatonic, 'dutifully dull
and derivative'. Seeing her as drained of divinity, which
in fact Mary never claimed for herself, any more than the
Church claimed for her, Daly sees 'patriarchal paradise'
as the reward of her 'perpetual paralysis'. Daly's taste for
alliteration, irresistibly reminiscent of Old Time Music
Hall, does little to enhance the seriousness of her case.[1]

In Six New Gospels, Margaret Hebblethwaite presents
a fictional portrait of Mary, after the style of a soap-

opera, in which she makes Our Lady admit to very mixed feelings about her pregnancy, which she describes as 'not exactly planned'. She says that subsequently the baby in her womb brought her feelings of great joy. In an extended footnote, Hebblethwaite quotes Jane Schaberg's 'original' interpretation (Hebblethwaite's term) that Mary's conception may have been the result of rape, and suggests that this would indeed have been an instance of God's 'transforming power', bringing good out of evil.[2] In that case, one asks, who was the rapist – God himself, denying the autonomy of a human being at this signal moment in the history of the world? Or was it a human male, in which case, Jesus could not be the son of God, in more than a general sense. It appears that Schaberg's interest, apparently considered seriously, if not indeed, endorsed by Hebblethwaite, is that Mary's motherhood was sacred but lay outside the 'patriarchal' family – that Church-endorsed concentration camp, so feared by feminist theologians.[3] St Paul warned the Galatians about adhering to 'new Gospels' (Gal. 1.6–9).

Mary Grey comments that, because the birth of Jesus is presented as miraculous, extraordinary and pain-free and because Mary is venerated as especially blessed, none of this has helped ordinary women. Nevertheless, she does admit that, at a popular level, there has always been great interest in the birth of Jesus at Bethlehem.[4] An extraordinary, miraculous event the Incarnation certainly was, but I am unaware of any authoritative statement to the effect that the birth was painless. Down the centuries, mothers in childbirth have prayed to Our Lady – undeterred by the differences between them and the Mother of God.

For the small body of feminists in the Church, their thesis remains that the Church has failed to understand or promote women in general, while venerating Mary in particular. It is hard for them to see Mary 'plain', without the baggage of hostility and resentment that has become their stock-in-trade.

Ruether sets out her theme as follows: that mariology exalts the virginal, obedient, spiritual feminine and fears

all real women in the flesh.[5] This is a false dichotomy since all living women are 'in the flesh', whether they are virgins, obedient to the Word of God, with deep spirituality or not.

Mother of the Gods

Some feminist theologians, including Rosemary Ruether and Karen Armstrong, see the devotion to Mary as deriving from the worship of the mother goddesses of antiquity, especially that of the Egyptian goddess and her son Horus. It is the Earth Mother, in ancient myth, who brings fruitfulness and renewal. This idea is rather arcane compared with the familiarity of the Christian delineation of Mary, and against these assertions, Michael O'Carroll maintains that Mary was never, from the first, given divine honours. 'She was seen in a world of supernatural beings, whose term is the hereafter; they (the goddesses) were principles of biological fertility here and now.'[6]

In any case, as we have seen from the Babylonian creation story, the goddess typically comes off worst, defeated by the stronger male. Ruether claims to distinguish these traces of earth motherhood in feasts of Our Lady occurring in planting and harvest times. The feast of the Annunciation certainly comes in spring, the time of sowing – though it can be argued that the date reflects a count of nine months back from the feast of the birth of Our Lord, rather than a spring-sowing reference. I have been unable to trace an early feast indicating harvest – that of the Assumption does not seem apposite.

The Immaculate Conception

Rosemary Ruether speaks of the Immaculate Conception as being based on identification of female sexuality with 'the stain of carnality'.[7] The doctrine of the Immaculate Conception refers to the conception of Mary herself, not

to the virginal conception of her son. This makes her interpretation hard to understand.

In his *Meditations and Devotions*, John Henry Newman provides an apposite quotation:

> It is so difficult for me to enter into the feelings of a person who *understands* the doctrine of the Immaculate Conception and yet objects to it that I am diffident about attempting to speak on the subject ... Does not the objector consider that Eve was created ... without original sin? Why does this not shock him? ... All we say is that grace was given (Mary) from the first moment of her existence. We do not say that she did not owe her salvation to the death of her Son. Just the contrary, we say that, of all the mere children of Adam, she is, in the truest sense the fruit and the purchase of his Passion.[8]

One can imagine that the remark that the doctrine was based on a rejection of female sexuality would have left Newman speechless! The 'hermeneutic of suspicion' had yet to be invented!

Although the doctrine of the Immaculate Conception was not defined until 1854 and some earlier theologians had not accepted it hitherto, the doctrine is implicit in Luke 1.28, when the angel saluted Mary as 'full of grace'. She could not have been 'full of grace' except 'by virtue of the merits of Jesus Christ, Saviour of the human race, preserved immune from all stain of original sin', as Pope Pius IX proclaimed.

Original sin, according to the teaching of the Church, is not identified with actual sin, committed by individuals. All wounded human nature tends towards evil, since the Fall, save only that of Mary (and her Son). The *Catechism of the Catholic Church* quotes Pope Paul VI, who said that following the statement of the Council of Trent, he held that original sin is transmitted with human nature, passed on 'by propagation, not imitation'.[9] Since human beings are conceived through sexual intercourse, that is the method by which original sin is transmitted. It does not imply that sexual acts are *ipso facto* evil.

From her negative viewpoint, Rosemary Ruether attributes to the 'language of Catholic piety', the line describing the Blessed Virgin Mary as 'Our tainted nature's solitary boast'. The line comes, in fact, from one of the Ecclesiastical Sonnets of William Wordsworth.[10]

Sexuality and Mary

Ute Ranke Heinemann holds a doctorate in Catholic theology and was Professor of Catholic Theology at the University of Essen. She lost that chair for 'interpreting Mary's virgin birth theologically and not biologically', according to the biographical details supplied to her publisher. This presumably means that she believes that there was no virginal conception. She subsequently held the chair of History of Religion at the same university. In her book, *Eunuchs for the Kingdom of Heaven*, she accuses the Church of presenting Jesus as without joy or sensuousness, whose coming denied his mother the ordinary pleasure of sexual intercourse, leading to motherhood.[11] She believes that women are presented as inferior, only good for having children – unless they 'busy themselves with self-sanctification'. 'Self-sanctification' is not the primary concern of the religious sister or consecrated virgin, though sanctification is undoubtedly a by-product of their closeness to God. The condemnatory use of the word 'self' shows how easily ideas can be distorted.

Superfluously pointing out that women cannot produce children without having sexual intercourse, she quotes a letter from Pope Siricius to a brother Bishop in AD 392 in which he said that God would not have chosen a woman to be the mother of his Son if she would later be 'stained by male seed'. We need not accept this rather ugly statement as the reason why the Church teaches that Mary remained a virgin in perpetuity. Like other consecrated women (and men), she gave up a great good, that of a fertile relationship with her husband, for the greater good of direct and self-sacrificial service to God.

Some commentators believe they can discern that this

was Mary's intention even before the Annunciation. When the Angel said to her that she would conceive, she asked how it would come about. On the face of it, that is a strange question for a girl who was betrothed, to ask, and in Judaism betrothal was a serious commitment. One cannot imagine that a Jewish girl of that time was, like some Victorian young lady, totally ignorant of how babies arrived. The hint of an understanding comes from the early tradition, later validated by the Church, that she had dedicated herself to God from the time when she was presented in the Temple. We know that there were groups like the Pious Ones, who lived a life of direct commitment to God. Therefore some theologians deduce that Mary and Joseph had decided, before their betrothal, that they would live a life of sexual continence.

It makes Mary's response to the angel even more trusting. In accepting the pregnancy, she was not only putting her life in danger (unwed pregnant girls could be stoned to death) and laying herself open to terrible shame and perhaps the disbelief of her husband-to-be, but it ran counter to the style of life they had intended to offer to God.

Others see the story as being almost without conflict. Mary and Joseph were betrothed and expected to lead the usual life of married people. Mary accepted unhesitatingly the invitation of God to serve him by bringing his Son into the world. What did Mary say to Joseph? We cannot know. He wanted no public shame to fall on her and decided to divorce her 'informally'. But, guided by the angel, he too accepted the reality of her virginal conception and took her to his home – which completed the marriage in Jewish law. According to this view, it was all done swiftly and joyfully and the happiness of the young couple was not compromised by these disturbing marks of God's favour; rather the reverse. Their love for each other was not expressed sexually, but was sustained by the special grace of God, given to them both. God's Son and his Son's mother both needed a guardian and Joseph accepted that trust. The smiling medieval statues of Our Lady and the Christ-child seem to endorse this view.

Ute Ranke Heinemann will have nothing of it. She speaks only of what she calls the nonsensical hatred of marriage and the body – although, if that were the case, one would have thought that Mary's parents, St Joachim and St Anne, would have merited Church disapproval, not to mention later married saints (even twice married ones like St Thomas More, with his fine family). She maintains that the New Testament did not intend to describe the virgin birth as an historical event, claiming that Matthew and Luke use it as a metaphor. I do not know the grounds on which she makes this assertion. What is it a metaphor of, in her view? Is it closeness to God the Father? If so, that is to distort the reality of marriage.

Like Ruether, Heinemann questions Isaiah's prophecy, '... the maiden is with child and will soon give birth to a son whom she will call Immanuel' (Isa. 7,14, JB). She sees the prophecy as relating to some immediate event, the danger threatening King Ahaz, but she cannot point to any virgin whose child saved the king, although the king escaped the destruction threatened.[12] However that may be, the prophecy is so striking that it is not surprising that it was applied to the conception of Jesus, especially as there are no other virgin mothers mentioned in the Old Testament. Ruether comments that the verse in Matthew is an incorrect translation of the Greek, which should read 'young woman'. However, biblical commentaries say that 'virgin' is the translation of the Septuagint, the Greek Bible of Christian times. For a 'young woman' to conceive is too usual an occurrence for comment. If, in Old Testament times, a young girl conceived before she had her first period, this was sometimes described as a virgin birth and was, presumably, not uncommon in a time of very early marriages and no doubt late onset of sexual maturity. But Ruether finds herself forced to reject the much more important line in Matthew 1.21, when the angel said to Joseph 'She has conceived what is in her by the Holy Spirit'.

There are further scriptural indications of the virgin birth, in the list of forbears of Jesus in Matthew 1.1–16,

which ends with 'Joseph, the husband of Mary: of her was born Jesus who is called Christ.' If this is not intended to distance Joseph from natural fatherhood, it is hard to imagine what the evangelist had in mind. Luke 1 and 2 confirm the virginal conception. As O'Carroll puts it, 'Zacharias is told his "wife Elizabeth is to bear *you* a son and you must name him John" (Luke 1.13). To Mary, the angel said "*You* are to conceive and bear a son and *you* will name him Jesus"'[13] Joseph is not associated with the conception of Jesus: it is only after his birth that Joseph assumes the responsibilities of a father. It is, even then, Mary to whom Simeon speaks in the Temple (Luke 2.25–35) and it is Mary who, twelve years later, questions Jesus in his Father's House.

Ute Ranke-Heinemann cites the genealogies of Christ, establishing his descent from David, as proof that Joseph was the natural father of Jesus. But there is no proof, since legal adoption then, as now, made the adoptive parent a real parent in every way, except the biological.[14]

O'Carroll asks why the two evangelists should bother to narrate the virginal event with such attention to detail if it were not a fact and suggests that it is surely up to those who do not accept the Church's understanding of Christ's birth to explain why these stories were so carefully invented. The virginal conception of Jesus appears not only in the official creeds, but in popular stories as well and Ignatius of Antioch, Justin Martyr, Irenaeus and Clement of Alexandria, all writing in the second century accept it.[15]

We can grasp the necessity of the virginal conception of Jesus when we consider his two natures. He is both divine and human. If he had had a human father, he could only have called God his Father in the way in which any Christian can say 'Our Father'.

Perpetual Virginity of the Virgin Mary

Rosemary Ruether stoutly maintains that the New Testament does not mean to imply that Mary remained a

virgin for ever and she interprets a sentence in Matthew to mean that Mary and Joseph went on to have normal marital sexual relations. This is a matter of how we interpret the text. Some translations, including the Revised Standard Version, read 'He ... knew her not *until* she had borne a Son.' This, Ruether and some other feminist theologians, understand in the modern English sense. However, the Catholic Commentary on the Bible explains that the Hebrew *until* does not indicate what happened afterwards. 'The Semitic turn of phrase, while denying the action for the period preceding the verse, implies nothing for the period that follows it.'[16]

Oddly enough, Ranke-Heinemann thinks it worth mentioning that Jovinian (c. AD 388) believed that Mary did not remain a virgin, although he says Jesus was conceived as the Gospels say. Jovinian had, she says with approval, an almost *Lutheran* view of marriage and disapproved of celibates, urging consecrated men and women to break their vows and marry. As Luther described woman as a nail, fixed to the wall of the house, his championship of the sexual woman does not inspire total confidence.

The angel Gabriel told Mary that 'the power of the Most High will overshadow you' (Luke 1.35). O'Carroll links this with Ruth's request to Boaz to 'spread your wing over me' (which is itself a reminiscence of Genesis 1.1, when 'God's spirit hovered over the waters'). He describes the Jerusalem Bible and RSV use of the phrase 'skirt of your cloak' as inaccurate. He points out that in rabbinic literature, Ruth's life is often interpreted as having some reference to the future coming of the Messiah. Thus, he says, the Annunciation has a 'bridal character', a virginal, human spouse, giving herself entirely to God. As O'Carroll points out, the ordinary Christian loved and supported this doctrine from the first.[17]

All the Fathers constantly affirmed Mary's perpetual virginity, with only Tertullian in disagreement. The Eastern Fathers thought that Joseph was a widower with children, but this did not cause them to suppose that

Mary did not remain a virgin. By the fourth century, the Latin Fathers taught this doctrine so forcefully that it was never afterwards questioned until modern times.

Ranke-Heinemann takes literally the mention of the 'brothers of the Lord'. The Bible is full of references to 'brothers' – 'brotherhood' is one of the most sacred concepts of Judaism. But the word does not necessarily imply shared parenthood, but an extension of the sort of commitment that would be expected between natural brothers. St Francis of Assisi famously carried on this tradition when he spoke of 'My brother, the ass'.

There was no Hebrew word for 'cousin', so Jerome is justified in interpreting the 'brothers of the Lord' as more distant, though still close, members of his family. (Matt 3.40). If there were even step-brothers, as the Eastern fathers taught, where were they when the Holy family had to fly into Egypt? Why did they not go searching for the boy Jesus with Mary and Joseph? Above all, why did Jesus give his mother into the care of John, when he spoke from the cross, if brothers or step-brothers were on hand? It seems unlikely that they were all dead, as we suppose Joseph to have been by this time – they would have been a generation younger, after all.

Jesus, Mary and the Family

Feminist theologians have very strong feelings about sexual freedom and the paramount importance of sexual acts. They tend, therefore, to adopt a tone of excited disapproval of Christian teaching combined with a consciousness of superior knowledge over poor celibates. Rosemary Ruether, for example, speaks of the way in which the new Christians of the early centuries often speak of the negative status of marriage. In the Old Testament tradition of Judaism, hope was a corporate sentiment. Individual marriages were seen as a part of the life of the Chosen People. The coming of Christ refined the focus, so that individuals came to see Christ undergoing suffering for each person as an individual,

though each individual was also part of the people of God. This, in turn, rendered personal self-abnegation for the sake of the Kingdom a high ideal. The *Catechism of the Catholic Church* describes Jesus as the centre of all Christian life and that the bond with him takes precedence over all other bonds, whether familial or social.[18]

It is odd that Ruether can speak of an anti-sexual and anti-maternal framework, when Mary was conceived by natural sexual intercourse and that the virginal conception of Jesus was necessary if he was to be both God and man. Above all, our God was incarnated for our sakes, with a human body like ours and with all the psychological and emotional traits of the human personality, experiencing joy, sadness, exhaustion, hunger and thirst. St Joseph adopted the infant Jesus, so that they became a family. Jesus lived the hidden life of Nazareth with his parents, until he was about 30 years old. There is no recorded instance of any other occasion like that of his visit to the Temple, when he asserted himself against them. We may, perhaps, suppose that this was a time of preparation for his public ministry, rather than a time of conflict.

Rosemary Ruether boldly states that Jesus' preaching shows some hostility to his relations.[19] In my view, this is too literal an interpretation. The family in Jewish society was, and is, very strong, so that Jesus' emphasis revealed to people that their relationship to God had to take first place. This understanding covers Luke 14.26 where Jesus says that if any man comes to him without hating father, mother, wife, children, brothers, sisters and even life itself he cannot become a disciple of his. This is, however, an occasion where a certain knowledge the background is useful. According to the *Catholic Commentary on Holy Scripture*, Aramaic was a rather primitive language, though a vigorous one, much used in trade and commerce. It was the language spoken by Our Lord and it does not include comparatives. One could not say 'I love my father more than I love my dog.' One would have had to say 'I love my father; I hate my dog.' Although this makes for a dramatic utterance, certainly

more so than modern English, the underlying meaning is identical. The same interpretation illuminates the episode of the would-be follower, who asked leave to go and bury his father first, 'Let the dead bury their dead' and the occasion when his mother and relatives came to see him and he described 'anyone who does the will of God' as his kinsman. (Matt. 8.22; Mark 3. 33–35).

That the Church understands these harsh sayings as hyperbole – the duty of burying one's parents, in particular, was a sacred one for Jews – is made clear by the emphasis put on the goodness of family life. In *Gaudium et Spes*, the great document on the Church in the modern world, of the second Vatican Council, the Council Fathers name marriage as the beginning and foundation of human society. Husbands and wives are apostles in their own families, depending on the grace of Christ as they live out the mystery of human love and commitment. The health of civil society depends on these couples.

The Marriage Feast of Cana

Rosemary Ruether writes of the harsh response that Jesus gave to his mother at the marriage at Cana. She believes that Mary showed no understanding of the inner meaning that he was about to reveal.[20] According to some translations, he replied 'Oh Woman, what have you to do with me?' The *Catholic Commentary on Holy Scripture* points out that the literal translation should read 'What to me and to thee?' and comments that in all the biblical passages where these words occur in the Old Testament, they signify a major or minor divergence between the parties involved.[21]

Jesus addresses her as 'Woman', linking her with the woman of Genesis 1–2 so that she becomes the second Eve.[22] He used the same term at his crucifixion, when he committed her to the care of St John. If 'his hour', which he says has not yet come, refers to his saving death, the beginning of his public life, revealed in the miracle he

performs, sees him embarked on the Way of the Cross. It may be that one discerns here his human fear of what he must suffer – a small premonition of the Agony in the Garden. At the same time that he refers Mary back to Eve, he presages, with the title 'Woman', the Woman of Revelation, 'adorned with the sun, standing on the moon, with a crown of twelve stars on her head' (Rev. 12.11). It is significant that the book of Revelation comes, if not from John himself, at least from the Johannine circle.[23] The Marriage at Cana appears in John's Gospel alone.

Mary's response makes it evident that she did not understand his words as a rebuff and had complete faith in him. Her confidence in him and her loving closeness allowed for and understood anything he might say to her. This dialogue links her intimately with her Son's salvific mission. Water is changed into wine at a feast: wine is turned into the body and blood of Christ at a supper. The incident at Cana, far from being a trivial matter of social embarrassment, reveals layer on layer of the economy of salvation.

Eve/Mary

In considering Mary at Cana, I have looked at the concept of Mary as the second Eve. Ruether, who has written a good deal about Our Lady, describes Mary as the original good woman before nature was divorced from the spirit. She goes on to question what she sees as a male belief, that female disobedience was the cause of sin and death.[24] That is not what the Church teaches.

St Paul writes with clarity '... sin entered the world through one man ... Adam prefigured the One to come ... as one man's fall brought condemnation to everyone, so the good act of one man brings life' (Rom. 15.12–18). In this instance the word 'man' is gender specific, that is, male. Ludwig Ott confirms that 'Adam's sin is trans-mitted to his posterity'.[25] The Eve/Mary reference is inferred from the Gospel, but the Adam/Christ reference

is clearly stated in Pauline writings. It is also more common to find attribution of the original fault to the man, rather than the woman – though many feminist writers seem to find this hard to believe.

I would not want to claim that no man, clerical or lay, ever stated that Eve, the first woman, was responsible for the Fall or that later women shared that responsibility. *Mulier est hominis confusio* ('Woman is the cause of man's downfall') was an off-quoted medieval tag, which Chaucer used with his tongue well in his cheek.[26] It is not, however, part of the Church's teaching.

Mary as Disciple

The fact that the Synoptic Gospels do not mention Mary on Calvary does not mean either that she was not there, nor that she lacked belief in the mission of Jesus – though for some reason, Rosemary Ruether thinks that Jesus' family became disciples on his death. I do not find any firm evidence for this statement. Luke clearly associates her with the crucifixion, when he recounts the words of Simeon in the Temple, as she presented Jesus: 'and a sword will pierce your own soul – so that the secret thoughts of many may be laid bare' (Luke 2.35).

The account in St John's Gospel of the words of Jesus to Mary and to John attest to her spiritual participation in the crucifixion and, if John represents the Church, Mary becomes the mother of the church, because she is given to him as mother. She is also 'the archetype of the Church because of the divine maternity. Just like Mary, the Church must be Mother and virgin ... The Marian profile of the Church precedes that of the Petrine (the apostles) without being in any way divided from it or being less complementary.'[27]

Feminist theologians tend to see Mary as a poor role model for women in general and especially for women who are neither mothers nor virgins, often contrasting Mary 'of Nazareth' with Mary Magdalene. Gnostic texts often exalt the latter as the especially loved disciple of Jesus. It was not

to her, however, that Jesus spoke from the cross. She was given the great grace of being the first to greet the risen Lord. The Gnostic tradition understood this meeting with the Lord as evidence of the right of women to ordination to the priesthood, sometimes described as the right of women to an equal place in Church structures. It is also suggested that Mary Magdalene is represented as a reformed prostitute, because she is a role model for women whom later Church leaders probably choose to ignore, assertive women who do what they want; in short an exercise in character assassination, master-minded by the Church. However, that does not describe the common profile of prostitutes, most of whom are, apparently, dominated by the men who run the business and take most of their earnings.

The Assumption of Our Lady

With an odd infusion of literalism, Rosemary Ruether accuses the Church of adducing the doctrine of Mary's assumption into heaven for her own triumphalist purposes. Ruether describes how the grace of Christ is 'funnelled' through Mary's 'neck' to Christians still alive.[28] My understanding is that Mary is called the Mediatrix of all Graces because she mediated the coming of Christ through her own body. This reveals, among so much else, the goodness of the body-person. Mary was able to receive the grace of her son so directly that her body did not have to decay. This doctrine, though undefined until 1950, was held by all Christendom and formed a mystery of the Rosary as St Dominic promoted it in the early twelfth century.

Our Lady Down the Ages

There is ample evidence that Our Lady has been venerated from the time of the apostles onward. It is not fanciful to imagine how the very first Christians must

have loved her and how Luke coaxed the stories from her that she had been 'pondering in her heart' – a greater woman than any celebrated in Judaism; a real woman, not an arbitrary goddess, sometimes benevolent, but unpredictable, from the pantheon of Greece or the deities of Rome.

Karen Armstrong[29] remarks on what she describes as a 'quiet revolt' in the Middle Ages against the strong, masculine tone of much of Christian life. She believes that people wanted to experience faith from what might be called a 'feminine angle'. Be that as it may, it is certainly true that the Middle Ages saw a wonderful flowering of devotion to Our Lady in sculptures, paintings, the music of church motets and Masses, in churches dedicated to her and in many prayers and sacramental acts – May processions, October rosaries, novenas in her honour and in intercession and so on. All these gave a richness and variety to the Christian life, in the churches and in the home. Karen Armstrong sees it as a strong psychological rejection of the 'patriarchal' ethos and quotes the psychologist, Jung, who considered that the definition of the doctrine of Our Lady's Assumption into heaven was the most important event since the Reformation. People outside the faith are often surprised when something that the Church teaches as true is recognized as psychologically valid! The treasures of religious truth are revealed in Mary, as well as in the Trinity. But a great hostility to Our Lady is revealed in many feminist writings. They see her obedience as unjustified, ignoring the fact that Our Lord showed obedience to his Father, even in the agony in the garden.

Rosemary Ruether, in a series of unsupported assertions, claims *inter alia*, that males combine womb envy with womb negation and that ascetics fantasize that by escaping the female world of sexuality and birth they will avoid mortality![30] This is idiosyncratic to say the least! Both Sophocles and Freud indicate that the death of the father and marriage with the mother are inherent male ambitions, if not fate. There is also good, if anecdotal evidence that having children is seen as a way of cheating death

through one's posterity. The sub-text to this, it seems to me, is a dislike of Mary's virginity, an uneasiness at the thought of sexuality trammelled either by asceticism, as a manifestation of the love of God, or by children, seen as gifts of God, born to his greater glory. Whatever may be the difficulties of individual ascetics, asceticism itself is not defined by fear of the sexuality of women.

The Mary Feminists Like

Mary is invoked in aid of the protest theology that Mary Grey, for one, sees as essential. No one can doubt that we should join Mary in expressing solidarity with the poor, but the Magnificat has a rich ambivalence, since it refers not only to the material 'good things', but to the whole human condition, which is not co-terminous with liberation from political or social oppression, nor yet discrimination on grounds of sex. The Magnificat is primarily about the relationship between God and man.

Justice and freedom from oppression and want must be among the concerns of Christians. Men and women suffer in different ways in different cultures. For the most part, feminist theologians are not much concerned with the oppression women suffer in the affluent Western world, through its anti-marriage, anti-procreative bias. It is not only women who are oppressed; men can also suffer; husbands are sometimes battered by their wives and by their bosses at work. They can suffer from having no work at all, with its consequent loss of self-esteem. But oppression is not inevitable for either sex in most cultures and would not occur, if the teaching of the Church was upheld.

Rosemary Ruether looks to 'Liberation Mariology' to assert the universal oppression of women and women alone. To counter that oppression, she hopes for support, for dignity, for 'self-actualizing' (which I take to mean self-awareness in action), and work-sharing.[31] I am afraid 'work-sharing' resembles the little mouse the mountains opened to reveal! She does, however, recog-

nize that Mary's giving birth can be a symbol of the Church, because it was a free act of faith. Indeed, so it was.

Notes

1. Mary Daly *Gyn/ecology* (Beacon, 1978), p. 88.
2. Margaret Hebblethwaite, *Six New Gospels* (Geoffrey Chapman, 1994), p. 22.
3. Hebblethwaite, *Gospels*, p. 23.
4. Cf. Mary Grey, *Redeeming the Dream* (SPCK, 1989), p. 143.
5. Rosemary Radford Ruether, *The Feminine Face of the Church* (SPCK, 1979), pp. 4ff.
6. Michael O'Carroll, *Theotokos* (Glazier, 1982), p. 272.
7. Ruether *Feminine Face*, p. 7.
8. J. H. Newman, quoted in E. Breen (ed.), *Mary the Second Eve* (Sandgates Convent, 1977), p. 10.
9. *Catechism of the Catholic Church* (Geoffrey Chapman, 1994), 419.
10. William Wordsworth, *Collected Poems* (Oxford University Press, 1950), p. 340.
11. Ute Ranke-Heinemann, *Eunuchs for the Kingdom of Heaven* (Penguin, 1990), pp. 4ff.
12. Ranke-Heinemann, *Eunuchs*, p. 29.
13. O'Carroll, *Theotokos*, p. 375.
14. Ranke-Heinemann, *Eunuchs*, p. 30.
15. O'Carroll, *Theotokos*, p. 358.
16. *Catholic Commentary on Holy Scripture* (Nelson, 1953), p. 856. Irenaeus, in C2, states that Matthew wrote in Anamaic, p.851.
17. O'Carroll, *Theotokos*, pp. 357–9.
18. *Catechism*, 1618.
19. Ruether *Feminine Face*, p. 7.
20. Ruether *Feminine Face*, p. 33.
21. *Catholic Commentary*, p. 984.
22. R. Nesbitt, *Mary, Mother of the Church*, Faith Pamphlets.
23. J. Leslie Houlden, *The Johannine Epistles* (A. & C. Black, 1973), p. ix.
24. Ruether *Feminine Face*, pp. 151–2.
25. Ludwig Ott, *Fundamentals of Catholic Doctrine* (Tan Books, 1960), p. 108.

26. Geoffrey Chaucer, *Canterbury Tales* (Cambridge University Press, 1933), pp. 237ff. Chaucer's tale of cock and hen in 'The Nuns' Priest's Tale' gives a splendid and funny picture of a very equal medieval marriage. Chaucer's world was an entirely Catholic one and the negative view of marriage often attributed to the medieval Church is not reflected here. Not that the Church would have approved of Chanticleer's harem!

27. John Paul II, cited in Nesbitt, *Mary*, p. 5, cf. *Catechism*, 773.

28. Ruether, *Sexism*, p. 144. Ruether is quoting, though she does not acknowledge it, a remark of Fr Faber's on the Assumption. I have to confess a preference for a less literal and specific interpretation.

29. Karen Armstrong, *The End of Silence* (Fourth Estate, 1993), p. 213.

30. Ruether, *Sexism*, p. 144.

31. Ruether *Feminine Face*, p. 55.

5

Women's Rites

Praise the Lord, all nations!
Extol him, all peoples!
Psalm 117

The Need to Worship

No human being is entirely autonomous. He or she is conceived willy-nilly by his or her parents and cannot guarantee the date of natural death. Thus it is that the need to acknowledge the existence of a higher power, on whom all beings are contingent, is an almost universal urge. When a Creator is perceived, however dimly, mankind bends low before him. To give thanks to a deity for the growing blade of corn and the ripened ear seems to have come naturally in pre-historic times, when the farmer realized that the process of growth and maturation was out of his hands. He could help the process, but he could not make certain the desired result.

Men and women recognized that the sun and rain did not originate with them. They observed the pattern of the seasons, the annual renewal, a time to rejoice and a time to mourn, when the harvest was over and the hard times of winter returned again. The very early rites, like that of Eleusis, which involved a silent cutting of the corn, appear to record thanksgiving for harvest. There are also many 'Ascension' rites, found in pastoral and hunting cultures, which concern death and resurrection – life feeding on death.[1]

There may have been tribes who lived, happily and naturally, through the cycles of growth and decay

without quarrelling or seeking to manipulate the natural order. However, many of the earliest stories involved conflict, greed and jealousy – a constant trinity of defects seemingly endemic to human nature since the Fall. The outcome of these negative feelings was for man to try to trick God (or the gods) by magic, trying to force him into some course of action by clever manipulation. Magic, therefore, is not spontaneous but calculated. It is designed to assert man against Creator, by holding on to a space that the individual considers his own, which he guards jealously, a stockade behind which he can hide, erected to exclude the Deity.

In early times, man can be said to have expressed his dependence on someone outside himself either spontaneously or in an ordered and ritualistic way. Spontaneous acts are self-evidently unpredictable, so that ritual comes to play an important part. It is soothing to the spirit and provides a rhythmic pulse, which serves to console. Many contemporary people claim to feel no urge to worship (except perhaps in moments of great anxiety). This may be because our society provides many distractions, which absorb the imagination and pass the time so effectively that the basic perception of human limitation is overlayed. Nevertheless, we can still say worship is necessary to human beings.

According to Bouyer, there sometimes comes a point at which 'man loses the faith that animated his rituals' and when this happens, he comes to miss the exaltation and emotion of offering sacrifices and acknowledging powerful beings of another order. He then seeks to re-create the emotions that he once experienced, without the beliefs in which they were grounded. We need not be surprised that the sense of mystery which is at the heart of religious experience still touches people in the contemporary world, though, like the seeds in the parable of the sower, it can be choked by the weeds of everyday existence.

The Psalms

In all world literature, there is surely no body of writings that express the dependence of man upon God as clearly and movingly as the Psalms:

The Lord has done great things for us;
Indeed we were glad. (Ps. 126, RSV)

We hear the psalmist expressing our fears:

Save me, Oh God,
For the waters have come up to my neck.
(Ps. 69, RSV)

expressing our confidence:

The Lord is my shepherd, I shall not want.
(Ps. 23, RSV)

and our anxiety:

Lord, let me know my end and what is the
 measure of my days
let me know how fleeting my life is! (Ps. 39, RSV)

Like a child, he cries – as we all cry:

I waited and waited for Yahweh,
now at last he has stooped to me. (Ps. 40 JB)

The Psalms express the personal nature of each individual's relationship with God. The human condition is always uncertain, often painful, but with a surging hope, inexplicable outside the life of faith. Ronald Knox wrote that all great pagan literature looked back to a golden age. Only the literature of the Jews looked forward to the future. The Psalms form a rich treasury of hope.

Just as the Genesis stories of creation are far above the rather indecorous and anecdotal creation stories of other Near Eastern peoples, so the Psalms evince a nobility which is unique and remarkable. Christianity is much the richer for having adopted them as part of the liturgy of the Church.

What is Liturgy?

The liturgy is the public service of worship in the Church. The first document of the Second Vatican Council is the *Constitution on the Sacred Liturgy*. The Constitution says that the liturgy of the Eucharist in particular makes 'the work of our redemption a present actuality' and describes the liturgy as the means by which we are to express the mystery of Christ in our own lives and also show it to others. It speaks of the Church as both human and divine, 'present in the world, but not at home in it'. The liturgy builds up the faith of those who live it, and also strengthens them to tell of God's love to those as yet outside. It reminds us that after Pentecost, all who were baptized followed the teaching of the apostles 'in the breaking of bread and in the prayers' (Acts 2.41–47). Christ is himself truly present in the Eucharist, body and blood, soul and divinity. In different ways, he is also present in the person of the priest at Mass. He is there in all the sacraments; in the Scriptures and when the Church gathers together to pray and to sing. As Augustine said, to sing is to pray twice.

All this reflects the great importance of the liturgy for the Christian life, and in the same document, the council Fathers speak of our having a foretaste of the heavenly liturgy celebrated 'in the holy city of Jerusalem' to which we are journeying. This reveals that most important element in liturgical prayer – reverence. Liturgical celebration is not an exercise in dramatics, or bonhomie, though it includes both drama and fellowship. It may use cultural elements suitable to a particular congregation. It has no need to be innovative, but it needs to reflect the wonder of the ever-renewed Christ event even where the liturgical celebration is not that of the Mass. How do feminist liturgies shape up to these requirements?

Feminist Ideas of Worship

Some feminists speak of their need to worship in ways

that are relevant to them as women. Since our creaturely position before God must be the same for men as for women, there is a difficulty here. In practice, it sometimes means that they see no reason why women should not offer the Holy Sacrifice of the Mass, sometimes it means that they want an unordained priesthood, sometimes it is because they want to worship 'the goddess', or because they feel that being a woman puts them at a disadvantage.

In a review of a book by Joan Doyle Griffith, called *Reflections in a Woman's Eye*, the reviewer quotes the author as saying that what women in 'Women Church West' seek to do, is to change 'patriarchal society' radically. This is scarcely the function of liturgical celebrations, but it appears that the sub-title of the book is *Experiments in Women's Celebrations, Rituals, Worship and Ceremony*.[2]

Just as feminist definitions of theology leave out God, feminist liturgies tend to concentrate on the participants rather than the Almighty. Rosemary Ruether defines 'Woman-Church' as a gathering of women 'who are church, empowered ... to define their own religious needs' and to organize themselves to serve them.[3] This reveals an exclusivity which the Vatican II document, *Lumen Gentium* (The Light of the Peoples) firmly denies. It states that Christ, 'the one Mediator', established and sustains the Church, through whom he communicates to all men. The word 'men', as in the long tradition of theological writings and translation in English, is inclusive. It continues, 'But the society structure with hierarchical organs, and the mystical body of Christ, the visible society and the spiritual community ... are not to be thought of as two realities. On the contrary, they form one complex reality.'

Ruether prefers to see the Church as a spirit-filled community, imprisoned by the organizational structures of the Roman Empire, which she believes were adopted by the Church in the late second century, much to the detriment of women, who she claims had a greater role in the institutional Church before that time. She states

definitively that Jesus did not found an 'institutional' church or establish the priesthood and sacraments.[4]

While she is not alone among twentieth-century theologians in this belief, it is not upheld by the documents of Vatican II. In *Sacrosanctum Concilium*, Chapter 2, the Council Fathers say without equivocation that Our Saviour instituted the eucharistic sacrifice of his body and blood at the Last Supper. This was in order to perpetuate the sacrifice of the cross throughout the ages, until he comes again. If the functions of the Church are to teach ('Go thefore and teach all nations', Matt. 28.29); to bring the grace of God to the People of God, through the sacraments, especially the Eucharist ('Do this as a memorial of me', Luke 22.19) and to forgive or retain sins (cf. John 20.23), these injunctions are all recorded in the words of Jesus in the Gospels. To dissociate oneself from them is to reject the canon of Scripture, or to establish a 'canon within or outside of the scriptural canon'.[5] It is to accept some texts as authentic and others as false, on the basis of their attitude to women.

If the Church authenticated texts which relegated women to a sub-human species, not made in the image of God, not redeemed by Christ, to be killed with impunity on the funeral pyre of their husbands, or branded with irons by their fathers, women would certainly recognize the Church as tyrannical and unjust. However, these are not her teachings. If confessors have urged women to uphold their marriage vows, even in the face of violence, the Church has never taught that women had to endure anything their husbands did to them. Confessors, inevitably only hear a partial account. It may be that they are not always successful in discerning the full picture, from the account they receive.

It is when women reject the accepted canon of Scripture, a God-given resource for both women and men, that groups of women set themselves to invent separate liturgies for their meetings, and tend to reject those of the Church, which, essentially, have universal validity. The Mass is inclusive – Christ's passion is re-enacted, sacramentally for women and men alike. There is, of

course, nothing wrong with groups of people joining together in prayer relevant to their particular circumstances. Such prayer meetings, however, must yield precedence to the Mass.

Since Vatican II, the Church has better understood the importance of 'inculturation' – the use of different symbols, from different cultures, in the liturgy in order to make it more easily accepted by people in different parts of the world. The Church is universal, after all. But care must be taken, so that the essential elements of the Mass and the sacraments are never modified or changed. Whether the concept of inculturation is relevant to feminist liturgies must be in doubt.

Ruether sees the Eucharist as the elevation of a simple symbolic act of blessing and giving out food and drink, into the symbol of power to 'control divine or redeeming life,' although she comments, 'anyone could learn to do them [that is, the sacramental actions] in an hour'.[6] The *Catechism of the Catholic Church* says that Christ instituted the Mass in order to perpetuate his sacrifice until he should come again.[7] Ruether, however, sees the 'point about the Sacraments is not what happens to the bread and wine, but what happens to us'.[8] Once again, she denies the specific nature of the religious rite, the actual bringing to the altar of God himself, in favour of an encouragement to good behaviour. If we respond appropriately to Christ on the altar, we will love our neighbour better. But there is all the difference in the world between the two perceptions of what the Eucharist really is.

Women-Church

Ruether is, however, right in realizing the truth of the saying, *lex orandi, lex credendi* (the law of prayer is the law of belief), that is, the way we pray is dependent on what we believe – the two must go together) In *Woman-Church: Theology and Practice*, she describes the liturgies she writes herself or recommends as turning back to the natural

rhythms of 'pre-Christian' traditions, which she understands as being close to the natural world. To 'worship' nature is, however, a sterile activity, since nature, like ourselves, is created.

Since their object is to rid worship of what is perceived as a patriarchal bias, feminist liturgies go out of their way to avoid prayer to God the Father, though in a Rite of Healing for battered wives, mention is made of a cry to the 'God of our Fathers', which has not been heard.[9] A version of the Lord's Prayer addresses God as eternal Spirit, life-giver, pain-bearer, love-maker ... 'Father and Mother of us all ... in whom is heaven'.[10] Whether this is an improvement on the version Jesus taught us is certainly open to question.

The feminization of God is paramount in these liturgies and the more extreme ones speak of the worship of the 'goddess'. We are turned from an active God, creative in his transcendence, to God-in-creation, an immanent God residing exclusively in the things he has made. There is also a sense of exclusivity about them, a feeling that 'we know something that you don't know', that goes straight back to the Gnostics.[11]

Ruether allies the 'need' of feminist women for prayer and ritual with those of women who are seeking to revive the old religions of the goddesses. She says that Catholic women have come to recognize their need to have bases for women's consideration of theology and the practice of feminist rituals. There is an apparent dichotomy between feminist demands for separate rituals of worship, and their claim of equality in Church decision making and function.

Declarations

As we saw earlier, feminism was born in the United States, and its manifestations, well-documented and much published, are more extreme there. The numbers of female religious orders, most nowadays much diminished, are still, nevertheless, able especially in the USA to

provide women for jobs in theology departments of Catholic universities and colleges. They are the ones who attend the Women's Ordination Conference meetings, which have included parodies of bishops (women dressed up) showering blessings on writhing and down-trodden women (presumably also nuns), before throwing off their mitres and getting down on the floor with the women in happy amity.[12] They make it clear that they are not interested in the ordination of women to the existing priesthood, but seek a 'renewed' priesthood, non-ordained, non-sacramental, dependent, presumably, on the feelings of the participants.

The so-called UK Roman Catholic Declaration, which was promulgated at a meeting of between sixty and seventy people in London in 1996, reveal that the signatories want the Church to have a new attitude to women, with access to the ministerial priesthood, and at the same time that they want the priesthood of all the baptized to be acclaimed! They do not, however, say how they distinguish between the ministerial priesthood, to which women are to be given access and the priesthood of all the baptized to which women would anyway belong!

Although Mary Grey expresses her belief that 'Goddess-spirituality' has much to teach Christianity, she also deduces that it can turn women away from the world leaving them to gaze at their navels.[13] Sophia, Greek for Wisdom, often stands in for the goddess, though in the Old Testament Book of Kings, Wisdom is represented by Solomon (1 Kgs 3.1–28; 4.9–14).

In a 'Garden Liturgy', the female celebrant shares some of her experiences with the congregation and this is followed by a litany in which women and in this case, men, ask to be freed from passivity (women) and thinking that sexism is less of a problem than racism (men).[14]

Another Eucharistic liturgy entitled 'Feminine Aspects of the Triune God, Creator, Redeemer and Spirit'[15] begins with a prolix penitential rite, which talks of failure, not sin – of course, all sin is failure, but not all failure is sin – and after a few biblical readings, the participants are to be handed pencil and paper and given 25

minutes to fill in a questionnaire. The 'Leader' is to give them a few hints about how they are expected to respond. In characteristic style, she points out that God the Father is not male (quite right, though she omits to say that he is a spirit). She mentions the 'Establishment argument' that women cannot be priests and says it means that the priest's gender is more important than the many 'feminine qualities' she discerns in Christ. The Lord's Prayer is rewritten to begin 'Lord God, far above our understanding, father and mother of us all' and is to be recited before the 'Consecration'. The eucharistic prayer is to be said by everyone in words not too far distant from those of the Mass. What status is accorded to the elements thus prayed over was not made clear.

The 'do-it-yourself' method is favoured by feminist liturgists, which often include mutual absolutions, 'discussions' and personal stories. In one such, which was, incidentally, written by a man, but incorporating feminist principles, we also find two suggestions for prayers, under the heading 'Do this in commemoration of me'; one invokes Holy Wisdom, while the other speaks of Jesus, obedient unto death, 'receiving authority and comfort' from a woman.[16] We know that Christ's authority came from his Father (cf. John 17.1–3). The anointing at Bethany is a favourite text in feminist liturgies and writings. Jesus was categorical about the woman's action. 'She has done it for my burial', he said.[17]

Rosemary Ruether states that 'Woman-Church' is rooted in 'creation spirituality'. According to the *Encyclopedia of Catholicism*,[18] this calls on believers to co-operate with divine creativity in all areas of life. It differs from orthodoxy in that it downplays revelation and transcendence in favour of a belief in the cultures of matriarchal societies (doubtful entities, historically) and of indigenous peoples. It claims to challenge what it sees as spirit/body dualisms (spirit: good, body: bad), which have never been the teaching of the essentially incarnational faith. It plays down transcendence.

Ruether describes an ideal building for women's public prayer. It is to be circular, not to say inward-looking. It is

apparently to combine the features of a healthclub (though without the aerobics), and a conference centre (though she does not mention a bar). There would be a large circular room for liturgies, conferences and communal meals, a round crypt for rites concerning birth and death, a talking place, shaped like an egg and hot tubs and saunas, with a cold bath for cooling off. Ideally, there would also be little cottages in woodland nearby, with sleeping and creating areas. No chapel, apparently, no Blessed Sacrament, ever ready and waiting for us. The women who would use these facilities would have to be rich in spare time and with something of a taste for amateur dramatics. The preparation for some of the liturgies Ruether describes would take longer than that of a solemn Tridentine Mass with a cardinal as celebrant!

The liturgy called 'Reclaiming Menstruation' is one of the most characteristic. The rubric demands a green and a red candle for each woman. Each has also a bowl and a ball of red yarn. The candles symbolize the eggs, that are described as being born each month in the bodies of women in their reproductive years. There is a certain fine disregard for biological fact here. The red yarn serves to link the women together. They describe themselves as bearers of life and the yarn as the stream of power that unites them with each other and all women and with the 'powers of the universe'. These powers are not described.[19] Having spent some time telling stories of their monthly cycles, the women are to strip off and bathe with ritual movements in a convenient pool, 'blessing' the dying away and the regeneration. After this, they are to clothe themselves in 'bright robes of new cloth' – every time? It could prove expensive.

There is something cloyingly sentimental about all this. What is the 'stream of power' compared with the gifts of God? But we find no thanking God for the fashioning of women, body and soul, no joy at loving husbands, and the mutual pleasure husbands and wives give each other, no expression of wonder at the process by which children come to be, no amazement expressed at the delicate and

exact way in which they grow and develop in their mothers' wombs, no prayer to Mary, Mother of God, who as both virgin and mother is the model for all women. For women approaching physical decline, she offers a 'croning' liturgy, which begins 'We are casting Janet's circle, sisters all around'. Even without mention of eye of newt and toe of frog, this offering is unlikely to be universally popular.

In many women's liturgies, women are urged to tell their stories. On most occasions, confessional story-telling tempts the narrator to self-pity and often the listener to sympathetic rage. Whether or no such sessions are therapeutic is open to question. Many of the liturgies centre on 'points of tension or crisis', as a kind of cathartic play-acting. She notes that the Church does not have rituals for a woman who has been raped or battered, or a woman, or man who has been abused in childhood. She adds, tentatively, that one might consider rites of forgiveness and reconciliation with a rapist or batterer. Wisely, perhaps, she decides not to develop 'liturgies for this category'.

In Del Martin's 'Liturgy of Healing for a Battered Wife', women and men are to stand in a circle while the Presider says that marriage has often been a cover for violence against women. The crucifixion of Christ is made, by what she describes as a theology of victimization, into spiritual notions of sadism 'in males' and masochism 'in women'. This is a statement without validity, but one that causes great sadness to believing women. It is a parody of Christ's perfect self-giving in love.

The Presider in a prayer of reflection speaks of the importance of stripping both god and goddess of the masks of patriarchy. The victim tells her story and other women anoint parts of her body with perfumed ointment, saying that this hand, face, chest, etc. was created to feel and enjoy life. After repetition of this theologically inadequate sentiment, they call on the battered wife to be healed. How she is to heal herself, or what effect their intervention is supposed to have, is left unclear. But they

still do not pray for the woman, nor do they pray that the battering husband will come to repentance and amendment. Prayer was defined in the *Penny Catechism* as the lifting up of the mind and heart to God. Without that relationship to God, rituals are meaningless.

Ruether describes baptism as an exorcism, not of Satan, but of 'patriarchy'. In attempting to exorcise 'patriarchy', she describes a 'Rite of Mind-Cleansing from the Pollution of Sexism', using a broken pen to represent those women who were willing to discard their personal aspirations, because they accepted the value of being a mother-at-home. A make-up box symbolizes the girl who sees herself as a sexual object and a can of cleaning powder stands for the household drudge.

It does not seem to occur to Ruether that bringing up children and providing a happy, stable home for husband and offspring is most rewarding as well as being a work of the very greatest cultural value. It involves many skills and requires much ingenuity and can be lived at all social and educational levels.

Christian and Pagan

It is certainly true that at many moments of life we can be encouraged and uplifted by prayer shared with others. Christ promised he would be with any two or three gathered in his name. Indeed, before Vatican II, there was widespread use of blessings in special circumstances – on moving to a new house or for a woman in pregnancy. The latter differs from Ruether's proposal that ancient birth chants should be revived to link the woman to the Mother Goddess as Creatrix and thus to 'empower' the woman in labour.

Ruether is also keen that Christmas should not be confused with the Winter Solstice holiday. The child born in the stable leads her to hope for a messianic child of what she calls the 'new humanity'. She sees baptism as a turning away from oppression and says the Church should repent of its sin. Indeed, oppression is the only

sin she seems to acknowledge. She describes baptism as a free gift from God, but later on seems to endorse the Anabaptists' view that baptism has no efficacy of its own. All that is significant is the feeling of having been converted. This is, of course, a denial of the Catholic definition of a sacrament, which is understood to be a fruit of Christ's sacrifice on Calvary, bringing graces which come to us (provided only that we are in God's friendship) whether we feel anything about them or not.[20]

During a celebration of Holy Week and Easter in Holland, described in the *Catholic Women's Network Newsletter*, the sensibilities of those alienated from Christianity were considered by allowing them 'spaces' to insert images of their own during the liturgies – Ceres and Persephone for example, symbolizing death and new life.[21]

Symbols and Further Subjects for Liturgies

It is not easy to invent symbols. The rituals of liturgical worship in the Church are rooted in the facts of the birth, death and resurrection of Christ and the reality of the sacraments. Human life follows a linear course, a pilgrim's journey. A favourite symbolic act of feminist gatherings is the 'circle dance'. Dancing in a ring has always been popular, from the children's Ring-a-ring-a-roses onwards, but as a symbol it leaves one – well, going round in circles.

In another liturgy, a participant described their Eucharist. It was a large chocolate cake, which they decorated with symbolic smarties, each representing a good wish for the world. A Holy Week celebration included a 'roly-poly session' on Maundy Thursday, the Solemn feast of the Last Supper and institution of the Eucharist, in which those present hugged each other and hoisted one lady on the backs of two others who were on their hands and knees. Thus, among much wild shrieking and giggling, they learned to let go and to trust.[22] In one Holy Saturday ritual, all the women were covered by

blankets and then called out one by one and by name. Each had a candle and they all told each other 'You are the light of the world.'[23]

On the other hand one writer in the *Catholic Women's Network Newsletter* complained of the vigorous way in which the priest thrust the Paschal candle into the Holy Water at the start of the Easter Vigil ceremonies. Her sensibilities recoiled at the sight of waters penetrated. Her own preference for a metaphor of creation is tickling, rising to loud laughter and tears of joy.[24] The difficulty here is that nothing is created by tickling – except discomfort.

In *Woman-Church*, Rosemary Ruether publishes more specific rituals for particular occasions. She provides a 'Rite of Healing from an Abortion', in which the participants say that they wish to create life that is wanted and can be sustained. They hold that the woman who has undergone the abortion has made the best choice for her, omitting to mention that the smaller of the two human beings in the case had no choice. Then someone takes a watering can and waters seeds, which are then given to the woman.[25]

Florence Hays contributes an improbable ritual of divorce, in which the couple remember the good times and the bad, interspersed with biblical quotations. A 'Coming-Out Rite for a Lesbian' also describes her as the light of the world. In 'Covenanting Celebrations for Creating New Families', Ruether accuses society of hypocrisy towards young people and says it should overcome its hostility to their sexual relationships. She ignores Christ's condemnation of fornication, which he describes as among the evil things that come out of the heart of man, and appears to see no risks in such behaviour.[26] She is right to castigate societies which demand chastity of girls but not men, but does not mention that the Church applies the same standards to each.

A 'Covenant Celebration for a Lesbian Couple' begins with the Covenant Vows, in which each says she loves the other as a special woman and promises to respect her need for separate space. This gracious endorsement is

followed by an exchange of rings and the mutual assumption of the name Kinheart. The Methodist minister pronounces them joined in covenant before God – wife and wife.[27]

Even allowing for cultural differences, these rites have a fustian air of amateur dramatics mixed with group therapy about them. Their solemn banalities invite laughter, but the misuse of religious texts and the admixture of sacred Scripture and paganism is not compatible with Catholic Christianity.

In the Constitution on the Liturgy, the Church gives guidance on the authenticity of liturgical worship. It points out that, for well-disposed Catholics, almost every event in their lives is made holy by divine grace. It comes through the sacraments and sacramentals which derive their power from the paschal mystery – the passion, death and resurrection of Our Lord. Material things can be used, in almost every case, to the praise of God and to human sanctification.[28]

Feminist liturgies practically ignore Christ. Even the Holy Week rituals concentrate on the participants and their feelings rather than the events they commemorate. The immediacy of the sacraments, and the reality of the graces that they convey are pushed aside in favour of emotive display. These liturgies employ a debased language of religion and are religiose, not religious. They cannot nourish Christian faith, because they are not grounded in Christian belief.

The liturgical worship of the Church 'performs' the realities of faith. The Mass is no mere commemorative act; it is both the sacrifice of Calvary and the Last Supper in true, but mysterious reality. To be present at Mass, is like finding oneself in the landscape of the most beautiful picture one can imagine, or singing in perfect harmony with the heavenly choirs and there in truth, not in a dream! Mostly, of course, one lives in faith, but occasionally, a strange awareness comes to one, nearer to joy than sorrow, yet different from both.

Where I believe feminist liturgies fail of their object, is in their insistence on the outcome for women. Liturgies

are public worship and God must always be the ultimate object of our prayer. Even to Mary, Mother of God, we pray, seeking her help in our intercession to God. 'Therefore we, before him bending this great sacrament revere' (*Pange lingua*, Thomas Aquinas). This must be our watchword.

The Vocabulary of Prayer

If we use words at all in moments of private prayer, the words we choose may well be simple, childish, verging on the banal. We are pleased that no human being hears us. The spontaneity of such prayer justifies it and the fact that Jesus taught us, through his words to his apostles, to call God our Father gives us a confidence that we could not naturally aspire to. Jesus himself addressed his Father as 'Abba', almost a baby word, like papa or dadda. The *Catechism* reminds us that it requires a humble and trusting heart to become like little children and it is to them that God reveals himself.[29]

How we pray as a community is a different matter. In the Catholic Church, we do not have a tradition of long, extemporized prayer, though it is important to one strand of the Protestant tradition. When I have heard such prayer, I have been aware of a sort of ribbon development of meaning, each phrase almost desperately hanging on to the next in order to keep hold of the sense. The absence of structure is a weakness.

In face of the awesome nature of what we are doing, community prayer needs to reflect our humility before God, Creator, Redeemer and loving Father. We need to pray with reverence, in a way that is seen to be dignified and fitting and which can be understood without too much difficulty. The very Latinate form of some English, Catholic prayers of the last century make them sound artificial to contemporary ears, while some present-day hymns have a banality of expression, and often music, which is incapable of helping to raise minds and hearts to God. The manner in which we pray is important. The old

adage says 'How do I know what I think, until I see what I say!' The way we pray, mirrors our beliefs.

This concept has been well understood by feminist theologians and activists. They extend the 'hermeneutics of suspicion' from biblical exegesis to the language of prayer. As we saw in the first chapter, their avowed aim is what they see as the advancement of women. They choose to believe that the inclusive term 'man' excludes women. It *can* do so, in a context that distinguishes between a man and a woman. But it *need not do so* and has been used inclusively since Anglo-Saxon times. The context makes it plain.

There are plenty of words in the English language which are identical in form, but have different meanings. Man's best friend the 'dog' means both the species and the male of the species. I would guess that most owners of female dogs refer in ordinary conversation to 'my dog' rather than 'my bitch'! The word 'grain' means both what is in the ear of corn, and the arrangement of the fibres in wood or in meat. A star can be in the sky, or in a film. Brigitte and Peter Berger, the sociologists, are quoted as saying, most perceptively, in my view, that 'Sexist language ... is a theory that elevates infantile misunderstanding to the level of hermeneutics'.[30]

Attempts to avoid the dreaded word 'man' in prayer, lead to some rather contorted phrases, much use of 'people', instead of 'man' and often the passive voice rather than the active. The *Catholic World Report* compared versions of a Christmas card, sent out by the Pontifical Council Cor Unum in 1996, which contained a translation from a Vatican document in five languages. They used the word *l'homme, el hombre, l'uomo* and *mensch*. The English translation alone avoided the word 'man', coyly using the phrase 'those welcoming the presence of God ...'

Latin has two separate words; *homo* for the human race, and *vir* for the male of the species. This fortunate chance did not, however, provide automatic recognition of women's identity and talents. For many centuries, the Roman state gave fathers and husbands rights of life and

death over their daughters and wives. It was the Christian Church that chose Latin, the tongue of the people, as her particular language, so that the Church made no deliberate linguistic choice in order to put women down. That did not stop the editor of the *Catholic Women's Network Newsletter* describing the issue by the Association for Inclusive Language of an education pack as a 'political act'.[31] It is surprising that this complaint is taken so seriously by the English-speaking bishops and seems to indicate a high degree of literalness in their understanding of the language of liturgical prayer and perhaps, a certain nervousness in the face of belligerent women.

As a congregation, joining together in worship, our joint humanity matters more than our sex. It is one place where we join together without consideration of the differences between males and females, where 'man' is the appropriate word and 'he' the fitting pronoun. If changes to *horizontal* language – that is, the way we talk to one another – are part of a 'political' agenda, changes in *vertical* language – the way we speak to God – indicate a different theology. The one often leads to the other.

Notes

1. Louis Bouyer, *Rites and Mankind* (Notre Dame, 1963). cf.
2. *Catholic Women's Network Newsletter*, December 1995.
3. Eugene Bianchi and Rosemary Radford Ruether (eds.), *Towards a Democratic Church* (Crossroad, 1992), p. 194.
4. Cf. Rosemary Radford Ruether, *Woman-Church* (Harper Row, 1985), p. 33.
5. Francis Martin, *The Feminist Question* (T. & T. Clark, 1994), p. 211.
6. Ruether, *Woman-Church*, p. 78.
7. *Catechism of the Catholic Church* (Geoffrey Chapman, 1994), 1323.
8. *Catholic Women's Network Newsletter*, December 1991.
9. Ruether, *Woman-Church*, p. 104.
10. *Women-created Liturgies* (Christian Women's Resource Centre, 1st edn, 1987).

11. Gnosticism came less from Jewish and more from Syrian and Egyptian Hellenic thought. It was an attempt to look at Christianity in a philosophical context. It also had more than a dash of necromancy mixed in with it and saw matter as evil. It ended up more or less explaining Christianity away. Cf. Vivian Green, *A New History of Christianity* (Sutton, 1996), p. 14.

12. *The Catholic World Report*, January 1996.

13. Mary Grey, *Redeeming the Dream* (SPCK, 1989), p. 44.

14. *Women-created Liturgies*.

15. *Women-created Liturgies*.

16. P. Kettle, *Palm Sunday Rite* (Association for Inclusive Language, n.d.).

17. Modern textual criticism sometimes produces a Humpty Dumpty effect – 'words mean whatever I want them to mean, no more and no less'. If a commentator does not like the surface meaning of a passage, he or she may find reasons for its inauthenticity. The Vatican document on biblical exegesis warns of this. The Church is the guardian of the interpretation of Scripture, where it has bearing on the deposit of faith.

18. R. McBrien (ed.) *Encyclopedia of Catholicism* (Harper Collins, 1995).

19. Rosemary Radford Ruether, *Woman-Church* (Harper & Row, 1985), pp. 109ff.

20. *Catechism*, 739.

21. *Catholic Women's Network Newsletter*, September 1991.

22. *Catholic Women's Network Newsletter*, March 1991.

23. *Catholic Women's Network Newsletter*, June 1991.

24. Cf. Alison Gelder, *Catholic Women's Network Newsletter*, March 1997.

25. Ruether, *Woman-Church*, p. 162.

26. Ruether, *Woman-Church*, pp. 164, 178, 193.

27. Ruether, *Woman-Church*, pp. 196ff.

28. *Sacrosanctum Concilium*, 61.

29. *Catechism*, 2785.

30. Quoted by Fr Duggan, 'Inclusive language or "Femspeak"' *Association of Catholic Women Review*, September 1996, p. 3.

31. *Catholic Women's Network Newsletter*, March 1989.

6

The Ordination Question

The Church of Rome I found would fit
Full well my constitution
And had become a Jesuit,
But ...

(Anon, 'The Vicar of Bray')

Is Conviction Sufficient?

Much of the advocacy for the ordination of women to the ministerial priesthood comes in the form of personal testimony. It comes either from the women themselves who seek to be priests or from those who believe that women should be ordained and have met individuals whom they feel would fit the bill admirably. The latter speak most often of the quality of compassion, the flair in practical matters and the ability to enthuse others that they discern in their candidates. They also speak of 'leadership roles'.

Karen Armstrong quotes one of the contributors to the Anglican Synod debate, which led to a vote for the ordination of women, as making a 'moving plea' that in the mercy of Christ and for the sake of the Anglican Church, she should be allowed to test her vocation.[1] This begs the question of what criteria are to be used to 'test a vocation'. Matters of religious faith and personal integrity need to be probed, of course, and one hopes that similar enquiries are made of male candidates for ordination. But, in a sense, they are inadequate, because they make the candidacy too personal a matter. If the apostles were the first priests, and the Church has always held that they

were, they would certainly have failed these tests on at least two counts. They were not noticeably sympathetic to each other and the faith of most of them proved inadequate to face the horror of Calvary. They needed Jesus to help them even with their fishing! It was only later that their faith and love grew.

When a priest is ordained, the reality of that event lies in the fact that the grace specific to priesthood is brought down by the Holy Spirit, through the hands of the bishop, on to the poor human specimen before him. The grace which signifies that great gift (the power to bring Christ to the altar and to forgive sins) stays with him all his life long. That man will inevitably be a sinner, to a lesser (one hopes) or greater extent. He may even lose his faith, but his priesthood is marked all through him like the letters on Brighton rock, to his life's end. Even if he is later laicized, he remains, strictly, a priest. As the *Catechism* says, 'The vocation and mission received on the day of his ordination mark him permanently.[2]

So beyond the earnest and sincere desire to be a priest, the candidate has to be eligible. He must not, of course, be an open and obdurate sinner, living a life incompatible with God's grace. He has to be willing to accept the teachings of the Church and to be in communion with the Church. He has also to be in line with all the pastors of the Church, going back to the apostles – which means he has to be male.

The Importance of Tradition

The three great monotheistic religions of the world, Christianity, Judaism and Islam, are sometimes called 'The religions of the book'. In each case the teachings of the religion are said to be enshrined in the Bible, the Torah or the Koran. With Christianity, however, that is a misnomer. A book is a lifeless thing – even a sacred book. Even though the Scriptures are our major resource, the belief that there was nothing but the Scriptures (*sola scriptura*) was the hall-mark of sixteenth-century dissent and

has had the effect of continually splitting churches into sects, because of disputes as to the meaning of the written words. Postmodernist notions that a book is a different entity for each reader clearly have elements of truth in them. The Church's teaching function has been to explain Scripture within the context of each passing century, without being untrue to its original meaning.[3] The Church has a strong teaching tradition, on which we can rely, so that scholarly disputes over interpretation of Scripture should not touch our equilibrium. Pope John XXIII liked to say 'Unity in essential matters; liberty in matters still in doubt; and loving kindness in everything.'

Catholic Christianity does not rely solely on the biblical record, and polemicists for women's ordination, in as far as they invoke authority at all, see a veiled or hidden tradition of women's public participation in the rituals of the early Church. It seems rather as if they believe there must have been some such public involvement, because Jesus was so open and kind in his relations with women.

Since we have no evidence that Christ wanted to involve women as ministers in the rites of the Church when he instituted the Eucharist at the Last Supper, we have to look at the traditions of Christianity and consider how those traditions have been maintained. The Church's teaching has been handed down in the simplest way possible – and the most human. Just as a mother teaches her baby to talk by talking, the Church, as spiritual mother, has taught her priests through the apostolic succession of bishops – each generation instructing the next. Humanly speaking, some bishops and some priests have done it better than others, but the essential mechanics of this method are fool-proof and have lasted the test of time.

Social and Cultural Influences on Jesus – Women and Jewish Society

Priests have always been males. Was the maleness of the priesthood culturally or socially determined? Or did Our

Lord choose males for another specific reason? Did he 'make priests' at all or was this the result of the later influence of Roman thinking on a freer, less institutional Christianity?

Judaism has a very interesting attitude to women. The Genesis statement ('male and female he created them') guaranteed their full humanity from early times. It is well known that Jewish males had a prayer in which they thanked God they had not been born a woman. It is less well known that there was a rabbinic prayer which encouraged women to thank God for their womanhood.[4]

In less technically developed societies than our own, the business of getting food on the table each day, of making clothes, first spinning, then weaving the cloth, not to mention bringing up children, tending the sick (probably even making their own herbal remedies first) and looking after the old, while sweeping the house, kept women pretty busy. But the essential nature of women's work was evident. Judaism was rare as a society in that it underscored the value of women's contribution by domestic religious festivals, like the lighting of the Hannukah candles and the sabbath meal. Presumably, women took part in the preparation of the Passover meal (unless, like the tradition of contemporary barbecues, the men took over the cooking). The importance of the mother in a Jewish family is recognized to this day.

Jewish taboos in connection with women's fertility cycle are also well known, but often misunderstood. For instance, Alison Joseph, in her introduction to the book she edited, rather cheaply called *Through the Devil's Gateway*[5] states that the Hebrew word *tameh* should be translated 'separate' or 'set apart', instead of 'unclean', as it is usually rendered in English. This time of being set apart was welcomed, rather than the reverse, by women, as it gave them a time of respite and rest from their ordinary duties. Certainly Orthodox Jewish women attest that the 'time to refrain from embracing' makes the 'time to embrace', especially the first time in each cycle, special and reviving.

Rosemary Ruether, in her contribution to the same book, alleges that although arguments that women are impure at certain times are not explicitly mentioned in the statements coming from the Vatican about the ordination of women, they are implied.[6] I must state categorically that I have been unable to discern any such implications and when she says that, because of these, men and boys are preferred over lay women as lectors, she is simply wrong. Since lay readers (and eucharistic ministers) were allowed, after Vatican II, women and men have been equally eligible to perform these duties.

Jewish women, as we have seen, were not considered as less than human or outside the culture of Judaism, though their roles were limited. It is interesting that some had the freedom to walk with the Lord; of these, Mary Magdalene had been freed from demonic possession, others had been healed from sickness. A few may have been women of importance like Joanna, the wife of Herod's steward. These women supported Jesus with money and performed services for him – again there was no easy access to prepared food! We have also seen how freely Jesus spoke to women – perhaps even more freely than he did to men. It was to a woman that he first appeared after the resurrection. Women, however, were not among his chosen twelve. They were not at table with him at the Last Supper. This fact is used by those who seek the ordination of women as a sign that it was the society in which Jesus lived that made it impossible for him to make them his priests.

It is true that Israel had never had women as priests of the Lord. The Romans had them as did other Near-Eastern cultures, though, as we have seen from the Babylonian creation stories, the Jewish writings show much greater spiritual awareness. Karen Armstrong thinks that the Bible is unfair to the Babylonians and that accusations of temple prostitution are misplaced.[7] Baal was, however, certainly a fertility god and his rites were intended to produce a good harvest.

The Fulfilment of the Law

The picture that we have of Jesus in the New Testament is at once full and rounded and yet it is a glancing view. We see him as if caught in the frame of a film – clear and in movement, but cut off. He said of himself that he had not come to destroy the Law but to fulfil it and he was here surely distinguishing between the Law given by his Father to the Jewish people and the accretions to that Law which often served to weigh them down ('tithes of mint and dill and cumin'). He was to fulfil the expectations of the Jews from their earliest days, as the Messiah for whom they had been waiting. The fact that most of them did not recognize him must always make us ask ourselves whether, had we been Jews at that time, we would have recognized him either – this is a good lesson in humility and a proper safeguard against anti-Semitic prejudice.

The conventions that he chose to obey are all those to do with his mission as Messiah – reading in the synagogue on the Sabbath, going up to Jerusalem for Passover. Those he chose to reject range from eating corn, plucked in the fields on the Sabbath, to performing acts of healing on that day. He broke social, as opposed to religious convention, when he spoke to a woman, and a Samaritan woman at that, without others being present. When he overthrew the tables of the money-changers in the Temple, he was defying both cultic and social taboos. He claimed to be able to forgive sins. As the Jewish establishment told Pilate, he deserved to die for pretending to be the Son of God.

So here we have a man who obeyed only God's law: social and cultural convention he showed no interest in. Thus had he wanted to call women to be apostles, we can only suppose he would have done so. But he did not do so and the Church has followed him.

Did Christ Ordain Priests Anyway?

Karen Armstrong describes what she supposed happened when the first Christians came together to break bread. She postulates that these were simple, intimate gatherings at which someone – 'presumably, the host' – would break and bless the bread as the usual custom was at a Jewish feast.[8] This may well have been so: nevertheless before the year AD 165, when he died, Justin Martyr was describing a recognizable celebration of Mass in Rome (even down to the collection).[9] In any case, the two unique and essential functions of the priesthood are the celebration of the Eucharist and the forgiveness, or retention, of sins. It was Christ himself, we know from the Gospels, who gave to his apostles the graces to enable them to perform these sacramental duties (Luke 22.19. John 20.23).

Even after Pentecost, the apostles were not given total knowledge of what the shape of 'The Way' was to be, down to organization of dioceses, and the collection of Peter's Pence. They had to work it out for themselves, under the *guidance*, of the Holy Spirit. So the picture that Armstrong paints of the early Christians functioning within the framework of synagogue prayer does not invalidate the belief that Jesus founded his priesthood. The Church in recognizable form developed soon enough, as we have seen. But when, as we read in Acts 1, the apostles, led by Peter, came to choose a successor to Judas, they chose him from among the male disciples. Despite all the contrary indications, Armstrong maintains that the exclusion of women from ordination, as it became established, was more to do with social customs, the influence of Roman law and the necessity of not seeming to be socially provocative in difficult times, than anything else.[10]

The Time of St Paul

The Christianity described by Luke, who accompanied Paul on some of his journeys is immensely attractive, if, as

Karen Armstrong points out, rather alarming. There was
no room for half-hearted followers and when Paul, after
his conversion, took up Christ's standard, a new
complexity emerges.

Many feminist writers, including Armstrong, Ruether,
Scussler Fiorenza and others note the number and
variety of women mentioned. We hear of Tabitha, well
known for her good works, whom Peter raised from the
dead in the name of Jesus. There is Lydia, the seller of
purple dye and the bemused little maid, Rhoda, who was
so amazed to hear Peter's voice, when he had been mirac-
ulously delivered from prison, that she forgot to let him
in and ran to argue with her mistress, Mary, the mother
of John Mark, whether it was Peter indeed.

St Paul speaks warmly of Phoebe and Prisca, who were
busy about the Lord's work; Tryphaena, Tryphosa and
Julia. Prisca and Aquila (who may have been her
husband) are sent greetings along with Claudia and all
the brethren in 2 Timothy 4.19–21. Timothy's mother,
Lois and grandmother Eunice are commended for their
faith and for the way they have handed it on to him (2
Tim. 1.5). The same writers all quote St Paul's Letter to
the Galatians 3.28, the famous text in which he says that
there are no distinctions between the baptized, whether
they be Jew or Greek, slave or free, male and female,
because each one of the baptized is a person in Christ.
This text is often put forward as evidence for the ordina-
tion of women. It refers, however, specifically to baptism,
to which everyone has a right. It does not mean that the
Greek stopped being Greek, or that the slave was free of
his master, or that women lost their identity as women. It
is certainly true, as Armstrong points out that this was a
revolutionary concept, one of openness and freedom
which included women.

Armstrong also remarks that Paul as a fallible human
male fell back at least once on his old chauvinist attitudes.
Francis Martin, in his difficult but rewarding study of *The
Feminist Question* essays an explanation of Paul's writing in
1 Corinthians, where he praises them for keeping to the
traditions passed on to them and speaks of the male as

the 'head' of the female.[11] Martin says that this is not to
be taken literally and that Paul may have used the word
'head', because the tradition he was praising was that
men should pray with their heads uncovered and women
with their heads covered. A man bows his uncovered
head before God, while a woman covers her head as a
sign of 'her authority over her own life and actions'.[12]
Because the male was the first to be created, he says, he
images God. The female is also (though here implicitly)
created in God's image, but was moulded from man in
order to make 'community possible'. Furthermore,
though the first woman came from man, all other men
come from women.

As Martin writes, we confront the letters of St Paul as
we would a musical score without a key signature. The
interpreter can only try to place it in a key so that it does
not require too many accidentals – additional sharps and
flats. At a first reading, St Paul's letter to Timothy (1 Tim.
2:9–15) seems to confirm the worst suspicions that, for all
his brave words about equality in Galatians, he despised
women. He writes, 'During instruction, a woman should
be quiet and respectful. I am not giving permission for
a woman to teach or to tell a man what to do ...
Nevertheless, she will be saved through childbearing
...'(JB). It is not surprising that these lines are a bugbear
for many women.

If we try to put this text in 'key', it takes on a different
aspect. Francis Martin makes the assumption that St Paul
was dealing with a particular situation, in which, for
whatever reason, certain women were interrupting
community prayer. There were already gnostic tenden-
cies abroad which included the teaching that marriage
was contrary to God's purposes. Therefore the words
'women will be saved through childbearing' is a rebuttal
of that heresy.[13] This interpretation does not support
Mary Grey's belief that this text reinforces women's feel-
ings of inferiority. What it does support is the difficulty of
biblical interpretation by text alone.

The silence of women, however, was not total, and
Martin points out that the Greek word used implies calm-

ness, rather than silence. There is evidence in the Letter to Titus that some women were involved in training – older women were to teach younger ones, certainly by example, probably also by advice. St Paul reminds Titus of the qualities necessary in those whom he is to appoint in Crete as 'elders' and there is no mention of women among them (Tit. 1.5–9; 2.3–5). The belief that the first Christians enjoyed greater freedom and flexibility than the Church, as it developed under the influence of Roman institutions, allowed them and might therefore have included a priestly ministry of women, is not borne out in the writings of Luke and Paul.

The simplest reason for the reservation of the ordained priesthood to the male is the one given by the *Catechism*: that Jesus chose only males to be his apostles and in their turn, the apostles did the same. This succession makes the group of the apostles 'an ever-present and ever-active reality until Christ's return'.[14]

The Icon of Christ

The *Catechism* also says that the priest at Mass is 'as it were, the "icon" of Christ'.[15] An icon is more than a mere representation. It is a sort of prayer in itself, not like a magic talisman, designed to make things happen, but as an object worthy of respect, both because of the reverence with which it was made and the reverence with which it is regarded by people of faith.

In the celebration of the Mass, the priest is, at once, the means chosen by God through which the sacrifice of Calvary is re-enacted, 'in an unbloody manner' for the sake of all mankind and the channel by which the grace of God comes to us in the Eucharist. His is the unique privilege of bringing Christ to us, hidden under the forms of bread and wine. Why then is this privilege not give to women? We have no real need to look further than the unbroken tradition of the Church, but when we do look beyond, the lines of enquiry reinforce the Church's teaching, rather than the reverse.

At the altar, the priest stands *in persona Christi*, symbolically, the person of Christ. Symbols engage our imagination. Aquinas said that a symbol must approach as closely as possible to the thing symbolized. We would not use a candle as a symbol of the dark, nor a clod of earth to symbolize water.[16] Christ was a male, therefore it is more fitting that he should be represented by a male than a female. In fact any assumption of that role by women would, literally, be a travesty (etymologically, cross-dressing).[17]

St Thérèse of Lisieux

Among the great women saints of the different centuries, there has been much desire for sanctity, much generous self-giving, but no clamour for ordination. The stories of the early women martyrs reveal them in a rush to be with God. The religious orders of women in the Middle Ages and the centuries following the Catholic reform, provided them with opportunities to follow Christ, within or outside the religious enclosure. Convents provided them with a world of their own, albeit under obedience to their bishop. As unmarried women in the world, they would have had, until recently, very much less scope.

One apparent exception to this rule, often quoted by those who favour the ordination of women in the Catholic Church, is St Thérèse of Lisieux. In a way, she is an odd champion for them. If ever there was a saint traduced by over-sweet representations, it is Thérèse. Growing up in an intensely devout family, following her sisters into the Carmelite convent, dying at the age of 24 and proposing to shower roses from heaven, one would not expect her to call out for priesthood – nor would one expect feminists to welcome her as a sister under the skin. Yet she is on record as having said, 'I want to be a priest'. However, I have yet to see a feminist writer quote another phrase from the same passage: 'I feel as if I have got the courage to be a Crusader, a Pontifical Zouave, dying on the battlefield in defence of the Church.'[18]

Sr Lavinia Byrne, in *Women before God*, suggests that
the Church should take account of Thérèse's longings.[19]
The Church would have her work cut out. In the same
passage, Thérèse, writing to her sister Marie-Louise, also
a nun, in a hectic and impassioned way, expresses her
feeling that it is as if she was called to be a fighter, a
priest, an apostle, a doctor, a martyr, a crusader, a
Zouave 'dying on the battlefield', or with humility, like St
Francis, refusing the 'honour of the priesthood'. She
writes that she would like to be a missionary 'preaching
the Gospel on all five continents and in the most distant
islands, all at once'. This is clearly not a considered state-
ment; it contains contradictions and impossibilities. She
even thinks of all the different means by which she wishes
to be martyred – one is not enough!

At the end of the letter, she resolves the contradictions
herself. She falls back on St Paul's First Letter to the
Corinthians, where he says that love is the best way,
because it leads straight to God. She writes, 'Beside myself
with joy, I cried out "Jesus, my love! I've found my voca-
tion, and my vocation is love."'[20] The vividness and
intensity of her theology of love has led to the proclamation
by Pope John Paul II of Thérèse as the thirty-third doctor
of the Church – the third woman to be so honoured.

Inherent in the drive for the ordination of women is
the belief that women are snubbed by being excluded
from ordination. That is, of course, absurd. There is no
truth in the view that the sexes are identical, apart from
some minor physical differences, and that therefore
anything possible for one sex is possible for the other.
That is observably false. In the physical sphere, men
cannot bear children: in the spiritual sphere, women
cannot be priests. Both sexes, made in God's likeness, are
of equal value in his eyes.

Notes

1. Karen Armstrong, *The End of Silence* (Fourth Estate,
 1993), p. 216.

2. *Catechism of the Catholic Church* (Geoffrey Chapman, 1994), 158.

3. On the other hand, one weakness of the medieval Church lay in the comparative neglect of the Scriptures, which rendered her unfitted for the new challenges of the Renaissance and subsequent Reformation. The people were left only partially nourished. The cult of the saints, unbalanced by detailed knowledge of Scripture, was not, in itself, adequate. Admittedly, as literacy was confined to the few (and those were educated for or by the Church), it was a difficult task.

4. Cf. John Saward, *Thanks for the Feminine Association of Catholic Women*, 1989.

5. Alison Joseph (ed.), *Through the Devil's Gateway* (Channel Four Books, 1990), p. 4.

6. Rosemary Radford Ruether, 'Women's Body and Blood', in Joseph, *Devil's Gateway*, pp. 7–8.

7. Armstrong, *The End of Silence*, p. 15.

8. Armstrong, *The End of Silence*, p. 65.

9. Cf. Thomas Bokencotter, *A Concise History of the Catholic Church* (Doubleday, 1977), p. 53.

10. Armstrong, *The End of Silence*, p. 89.

11. Francis Martin, *The Feminist Question* (T. & T. Clark, 1994), p. 350.

12. How ironic, that nowadays, when women are concerned to express their autonomy, they have chosen to stop wearing hats in Church! I very much doubt if many women know why they used to cover their heads. The need for economy during the Second World War seems to have brought the change in custom.

13. Cf. Martin, *Feminist Question*, pp. 358–9.

14. *Catechism*, 1577.

15. *Catechism*, 1142.

16. Aquinas, *Summa Theologiae*, in *Selected Writings* (Dent, 1940), p. 89.

17. Like distinguished actresses, ill-advisedly, in my view, determined to play King Lear – or the fool.

18. The Pontifical Zouaves were a French corps, raised in 1860 for the defence of the Pope, and disbanded some years later.

19. Lavinia Byrne, *Women Before God* (SPCK, 1988), p. 108.

20. Cf. Peter McDonald, 'Did St. Thérèse want to be a priest?' *Homiletic and Pastoral Review*, April 1989, pp. 7–21.

7

Man, Woman and God

I looked for His symbol at the door
I have looked for a long while
at the textures and contours.
David Jones[1]

When we look at the theological concerns of feminism, we have to consider what we mean by man, as male and female, and the relationship of both men and women to God. Elisabeth Schussler Fiorenza recounts the distress of her daughter, aged 4, when she learned that all the excitement of Christmas centred on the birth of a boy! Her mother explains that they had always expressed strongly to their daughter their delight in having a girl. They had, unwittingly, no doubt, given their daughter an incomplete message.[2] Fiorenza, unconvincingly, in my view, claims that her daughter's 'rage' bore witness to the 'scars' that women carry when they come to realize that boys are the centre of the religious and cultural world. Fiorenza and her husband should perhaps have explained from the start that mothers and fathers are delighted to have whatever babies God sends. In this instance, they had the chance to explain how Jesus was a special baby, because he was the Son of God. The incident reveals a fatal tendency to over-egg the pudding!

We start, as Rosemary Ruether agrees, with a matter of faith for all Christians; that God made man in his own image, and created them male and female (cf. Gen. 1.26–27). Fiorenza, however, speaks of 'the assumption' that sex and gender differences are 'natural'. Her implication is that all but a few physical differences are

112

constructed by the society in which we live. She see all such observations of natural differences as really intended to support what she terms 'kyriarchal' domination. She coins the word from *kyrios*, the Greek for lord. She believes that the 'kyriocentric' way in which the differences between men and women are viewed serves to make legitimate the 'socio-political' system of 'kyriarchal' oppression.[3]

At the very beginning of sacred Scripture, the equality of value between females and males is revealed. It means that, with regard to the sexes, 'God does not have favourites – as St Peter found in another context (Acts 10.35). God's love is directed to women and men alike. Thus it is, as Pope John Paul II writes, that 'man can exist only as a "unity of the two".'[4] To be a person in the image and likeness of God involves existing in a relationship with the other 'I'. This is the first step towards some comprehension of the Trinity – God-in-relation. Mary Daly, however, in her book *Gyn/ecology* describes the 'christian trinity' (sic) as legitimizing male mating.[5] She chooses to ignore the fact that God is a spirit.

The relationship between man and woman necessarily involves complementarity and difference. Ruether understands that the statement 'all are one in Christ' refers to the effects of baptism, but she extrapolates from St Paul's words in Galatians 3.28 in order to claim identity of function between men and women in the Church. She alleges that the Church interpreted the essential equality between the sexes in a spiritual sense, and thereby made equality irrelevant in the social structure of the Church.[6] Both Ruether and Fiorenza blame the Church for the fact that many women get less well paid jobs than men do! Both writers emphasize how like women are to men – the differences between them they see as peripheral. Ruether, however, in another context insists on 'Women-Church', women's liturgies, women's system of belief and so on.

Differences between Men and Women

It is ironic that, in a society where the Church's teaching on sex is so often rejected (and Ruether rejects it, admitting that when she married, she decided that she did not agree with the Church's 'position' and intended to practise 'child planning' by artificial means[7]), the differences between men and women are revealed by contemporary anthropological studies to be deeply sexual in the widest sense, thereby confirming the Church's teaching. The once-fashionable epithet 'unisex' used of clothes and hair-styles, was a misnomer. Every cell in the human body has a sexual imprint (the gametes being a special case).[8] The physical differences between male and female provide a paradigm of other distinctions and Christianity, as an incarnational faith, takes the body seriously.

Schussler Fiorenza holds that by stressing the maleness of Christ, the Church 'blocks' women from participating in the fullness of their life in his image. She believes biology is too much stressed.[9] We are, however, made in the image of God, who is a spirit. We are not, in this sense, made in the image of Christ, who is God-the-Son. She quotes, without apparent disapproval, something written by Joanne C. Brown and Rebecca Parker who ask whether it is surprising that there is so much abuse in modern society when Christian theology images 'divine child abuse'[10] – presumably a reference to Christ's chosen sacrifice of himself on the cross.

An Anthropologist View of Human Differences

The anthropologist Philip Lersch characterizes males as 'eccentric' – in its semantic, not its popular sense – and asymmetrical, in line with the male XY chromosomal pattern. Females, he describes as having 'centrality', for which he uses the image of a circle round a point. Male activity resembles a line going from the centre of a particular subject out into the wider world. The circular

'centrality' of women reflects their stronger involvement in the rhythms of nature.[11] The philosopher Max Scheler comments that compared with the way in which a woman experiences her body, recognizing herself as 'in' it, a man 'walks his body around at such a distance from himself that it might well be a dog on a leash'. Buytendijk, also quoted by Hauke, describes women's glance 'resting' on things and absorbing them, while the male tends to focus sharply on the environment and to view things as objects before him.[12] His walk is more like the blow of a hammer. Female movement is characteristically more rhythmic and flowing.

From ordinary observation, one is aware that men and women have different patterns of speech. When men talk together on social occasions, they tend to speak of achievements and general topics, while women most often discuss personal relationships. Even very small boys show aggressive thrust in their play and it is tempting to suppose that the baby St Augustine observed, looking bitterly and enviously at a foster brother or sister enjoying his or her turn at the breast, was a boy.[13] Small girls tend to imaginative games, in which fantasy people interact, while boys most often favour mock battles of one sort or another.

Male forcefulness, however, can result in valour, good judgement, trustworthiness and protectiveness – all patriarchal values. Women are typically more concerned with the 'near world', the immediate circle, family, home and those in need. Jung points out that each person exhibits an unconscious 'mirror image' of whatever characteristics may be seen as typical of his or her sex, which reflect the characteristics of the opposite sex and this makes for a much greater richness and variety in human personalities and many more possibilities for human achievement.[14]

With a certain twentieth-century feminine reluctance, I concede that, in general, men are more attuned to the obvious leadership roles than women are, though there are many and notable exceptions. Women's influence is commonly felt in more diffuse ways. They can often gain a point by circling the subject, rather than by

confrontation of the opponent. They enjoy unique spheres of influence – the hand that rocks the cradle rules the world. I doubt if that is a popular saying in the last years of this century, but it contains a profound truth. The loving stability of a child's early years will mark him or her profoundly for the rest of life and the care that promotes that well-being is most suitably given by the mother – who has already had nine months of providing, more or less unconsciously, for her child. The seventeenth-century philosopher Locke, held that every individual came into the world like a blank piece of paper. Yet a baby is born able to recognize its mother's voice: the learning process begins in the womb. It is an awe-inspiring thought that the way a mother looks after her baby can influence society, when that child becomes adult. In turn, he or she helps mankind to produce a better world or hinders it from so-doing. Every mother influences the society of the future.

If the family unit is the 'cell' of society, the wife and mother is the centre of that cell. The qualities that women bring to motherhood are also brought to bear on other walks of life, in religious communities and indeed on life in the world. The contribution to the life of parishes, to charities and neighbourhoods made by widowed and unmarried women is incalculable and often not sufficiently appreciated. It is a sad development in our society that public acclaim is seen as the touchstone of the successful life. It should not be the Christian way.

The *Catechism* puts it clearly: man and woman share the dignity of being made in God's image. 'In their "being-man" and "being-woman", they reflect the Creator's wisdom and goodness.'[15] In opposing 'patriarchy', writers like Ruether and Schussler Fiorenza are, in some sense, rejecting one essential difference between men and women, since patriarchy, at its best, is fatherhood writ large.

Male and Female Archetypes in Contemporary Psychology

An archetype in the writings of Jung and his followers,

consists of an inbuilt mental structure which changes and grows in response to what it encounters as the person goes through the experiences of life. Some recent studies, by contemporary Jungian psychologists, have put forward four basic archetypes which they understand as underpinning the male. They are described as the King, the Warrior, the Lover and the Wiseman/Magician. Paul Vitz, a Professor of Psychology at New York University, endorses the view that those archetypes provide support for the idea of male servant/leadership. As Jesus said of himself, 'the Son came not to be served, but to serve'.[16]

Each one of these qualities is embodied in Christ, who is our model of God the Father. The King archetype indicates primal, but ordered, energy, able to furnish both blessings and fertility. Pilate asked Jesus if he was a king, to which Jesus replied 'You have said so!' (Luke 23.3) The Warrior shows forth controlled aggressiveness, which comprises courage, even in situations of life and death; fairness, defence of the weak. Jesus showed these qualities when he turned over the tables of the money-changers in the Temple and above all in his response to his passion.

We recognize Christ as Lover. The life of Christ is one entire exemplum of love. We have seen how he expressed love for the women in the Gospels; equally he expressed love for his apostles and wanted, in turn, to be assured of their love: 'Simon, son of John, do you love me?' He looked at the rich young man and loved him (Mark 10.21); he loved the children and took them in his arms; he loved his friend Lazarus and wept for him. As Magician/Wiseman, we know Jesus astonished people by the 'new things' that he taught and the authority by which he taught them.

In human males, each of these archetypes can be turned to good or to evil. Pope John Paul II says in his letter, *On The Dignity and Vocation of Women*, that the male's tendency to dominate is a result of the Fall.[17] Instead of domination, he needs to aspire to the condition of leader/servant, in imitation of Christ. In Christ, the archetypes appear literally to perfection, reflecting some of the attributes of God the Father.

There are similarly feminine archetypes, according to Professor Vitz. These comprise the Queen, the Wisewoman/Magician, the Defender and the Lover. Our Lady embodies these perfectly, as Queen of Heaven, Seat of Wisdom, defender of all who call on her, and guardian of the Christchild, in Bethlehem, as they fled into Egypt, at Nazareth. She is the epitome of woman's loving.

The Pronoun for God

According to Rosemary Ruether, a 'male' monotheism has so long been accepted that people have not noticed that it is odd to image God through one gender alone.[18] God, of course, as a spirit, is neither male nor female and yet the Church is surely right to use the male form of the pronoun in speaking of the Deity. On the face of it, it seems arbitrary to choose one pronoun rather than another for God. The reason, however, is not far to seek. The primal image that we have of God is that of the loving Creator, a transcendent being, who goes out from himself in order to create the world and mankind within that world. God is an independent reality, upon whom everything is contingent. He has made his creation and therefore cannot be *identified* with creation. It is, of course, true that God is also immanent, living *in* his creation, but this is contingent on his having made it in the first place. As Hauke points out, we learn about God from our perception of his work in the world, that is, his immanence, but we are always aware of his reality, separate from his creation.[19] To understand God as primarily or only immanent in creation, is to confuse Creator with the work of his hands, which is the position adopted by pantheism. The tree becomes God, because God is in the tree. Pantheism ultimately ties up the believer in the toils of his own existence: there is no way out: there is no freedom.

Francis Martin quotes three distinguished writers to support his striking statement that, transculturally, the male mediates transcendence and otherness and the

female mediates immanence and closeness – Mircea Eliade on religion worldwide; Gilbert Durand on images in general and Walter Ong as a socio-biologist.[20] As we have seen, God creates life outside himself, thus it is fitting that we use the male pronoun when we refer to him. Hauke points out, further, that men do not embody the transcendence of God, although they represent it. A man is not God. Women, however, are not only the symbols and emblems of creation, they are part of creation themselves! Thus, the statement 'God is mother' can only lead to adoration of creation and then to the worship of self as part of creation.

The *Catechism* states that the language of faith tells us two things, when we call God 'Father'; first that he is the transcendent origin of everything and second that he loves his children. It goes on to say that God's tenderness can be expressed by picturing him as mother, and this emphasizes God's immanence and intimacy with his creation. In truth, 'God transcends the human distinction between the sexes ... no one is father as God is father.'[21] The motherhood of God is necessarily secondary.

It is interesting to reflect that, not for the first time in the Church's history, an attack on a hitherto almost unthinkingly accepted doctrine, has caused Catholics to consider their beliefs and in doing so to find enriching insights into the faith, and in this case, the naming of God. If we need a simpler reason for calling God our father and using the male pronoun to refer to him, we have one in that Jesus told us to do so and did so himself. Indeed, he called him Dadda (Abba) (Mark 14.36).

Notes

1. From 'A, a, a, Domine Deus', by David Jones, published in *The Sleeping Lord* and reproduced by permission of Faber and Faber Ltd.
2. Elisabeth Schussler Fiorenza, *Jesus, Miriam's Child, Sophia's Prophet* (SCM Press, 1994), p. 35.
3. Schussler Fiorenza, Jesus, pp. 35ff.

120 *The Inner Goddess*

4. John Paul II, *The Dignity and Vocation of Women*, 7.
5. Mary Daly, *Gyn/ecology* (Women's Press, 1979). Daly claims that she chose deliberately the role of witch and madwoman, cf. Donna Steichen, *Ungodly Rage* (Ignatius Press, 1991), p. 299.
6. Rosemary Radford Ruether, *Sexism and God-Talk* (SCM, 1983), p. 35.
7. M. H. Snyder, *The Christology of Rosemary Radford Ruether* (Twenty Third Publications, 1988), p. 12.
8. Manfred Hauke, *Women in the Priesthood?* (Ignatius Press, 1988), p. 85.
9. Schussler Fiorenza, *Jesus*, p. 40.
10. Schussler Fiorenza, *Jesus*, p. 99.
11. Cf. P. Lersch in Hauke, *Priesthood*, pp. 94–6.
12. Cf. Buytendijk, 'Woman, Nature – appearance – essence' in Hauke, *Priesthood*, p. 94.
13. Cf. Augustine, *Confessions* (Collins, Fontana, 1969), p. 12.
14. Richard D. Gross, *Psychology* (Hodder & Stoughton, 1992), p. 924.
15. *Catechism of the Catholic Church* (Geoffrey Chapman, 1994), 369.
16. Cf. R. Moore and D. Gillette, *King, Warrior, Magician, Lover* (Harper, 1990), quoted in Vitz, 'Support from Psychology for the Fatherhood of God' *Homiletic and Pastoral Review*, February, 1997, 7–19, p. 19.
17. John Paul II, *Dignity and Vocation*, 10.
18. Rosemary Radford Ruether, *Sexism and God-Talk* (SCM Press, 1983), p. 53.
19. Hauke, *Priesthood*, pp. 142–3.
20. Hauke, *Priesthood*, pp. 142–3.
21. *Catechism*, 239.

8

Marriage, Sex and Feminism

Behold you are beautiful my beloved
truly lovely.
Our couch is green.
Song of Solomon (1.16 RSV)

Male and Female Sexuality

For a woman, sexuality is pervasive of her whole self, in a way that a man's sexuality is not. She is born with her potential as a bearer of future generations already fixed. Her eggs are in place. The story of much of her life tells of her ability to bear children. From her first period to her last, her body runs in a cycle of preparation, the lining of the womb enriched to be ready for new life, ovulation, and, if no pregnancy occurs, expulsion of the lining of the womb, in order to prepare for her next cycle. All these changes affect her feelings of physical well-being and levels of energy and calm. The end of her years of child-bearing bring other physical changes. Men have no comparable rhythm of life.

Even little girls behave differently from little boys. The greater physical power of the male has made him able to dominate the female, as well as the exterior world. But the other side of this power is its use in protecting the female and the young. It is characteristically males who push back the frontiers of knowledge, invent structures for societies and strategies to overcome barriers. They are also proud of their ability to provide for the well-

121

being of their wives, and keen that their offspring do well.

For women, help and protection are particularly and obviously necessary when they are carrying a child in the womb or rearing one in the home. It is absurd that some contemporary women are so keen to enjoy or perhaps assert, their personal autonomy that they deliberately embark on single motherhood as a feminist gesture. It is an act of folly and deeply damaging both to the woman herself and to her child. The child, always and in every circumstance, has the right to come first.

Men, however, are also deeply in need of support. We know from much contemporary reportage the effect of unemployment on males, denying them their sense of self-worth. We know that many men find it hard to adjust to retirement. All women, who have experienced a deep relationship with a man know how much men need reassurance that they are successful as males. These are the commonplaces of human experience.

Traditionally in most cultures, the promise to love and cherish a woman has preceded their sexual coming together. The current acceptance of casual or uncommitted sexual relations has inevitably weakened the trigger for the link between sexual activity and male protectiveness. It extends the time of youthful irresponsibility and adolescence for the male and for both male and female, it loosens the understanding of love, sexual desire and children. Sexual attraction has always been seen in a ribald way, as well as being recognized as something of primary importance. Now ribaldry has taken over and the beauty of love as something which involves the whole person is often difficult to see, even for the young people themselves.

We cannot describe it as 'animal', because in most mammalian species, if not in all, the female will only accept the male when she is 'in season'. Human beings have the God-given choices to make, not only the basis of a mechanical response to a time of fertility, but on a whole spectrum of considerations. One of these is the small percentage of a woman's reproductive life during

which she is actually able to conceive and her ability to observe the signals of this.

These are generalizations both as an ideal picture of the loving, child-bearing woman and her loving, protective spouse and of the late twentieth-century trivialization of sexuality. Traces of the Christian understanding of the good, however, are visible in the lives of most men and women, as far as one can judge from personal observation, from fiction and social statistics.[1]

The Church as Original Despot

Feminist writing, almost uniformly, expresses a sense of resentment at the teaching of the Church on marriage and sexuality. As we have seen, the dominant complaint of feminists *vis-à-vis* Christianity is that women have been oppressed by a male-dominated world, which includes a male-dominated Church. Ute Ranke-Heinemann says that the whole of church history 'adds up to one long, arbitrary, narrow-minded, masculine despotism over the female sex'.[2] Western civilization has grown out of Christian beliefs and practices, therefore the Church is commanded to accept the blame for the way in which these women believe themselves and all their sisters, without exception, to have been cheated out of their gender-indifferent birthright. When Simone de Beauvoir said that one was not born, but one became a woman, she implied that to be a woman was to be the equivalent of a slave or a wild animal in a zoo.

We have seen that the insights of anthropology, psychology and biology enable us to perceive that this is not the case and that the statement in Genesis, to which we find ourselves returning again and again, 'male and female, he created them' is luminously and self-evidently true and implies equality of value in both similarity and difference.

Women and the Church in History

The gibe that history does not repeat itself, but that historians repeat each other has some validity, in that we find the same picture of the Church recurring and the same stories repeated. For many, it is axiomatic that any text that *can* be interpreted in a sense that shows the Church oppressing women, *will* be interpreted in that sense. Even as distinguished an historian as Olwen Hufton accepts that the text of the first letter of St Paul to Timothy is misogynist. As we have noted, it may well be a pastoral instruction in response to specifically misleading teachings of a Gnostic kind, rather than evidence of the hostility of St Paul to women. She describes it as a 'foundation text in the history of women'.[3]

Hufton also speaks of paintings in which the serpent in the Garden of Eden is shown as having the face of a beautiful woman. She interprets this as evidence that the Fall of man was seen as an 'all-woman event'.[4] Another interpretation is, however, possible.

Milton, in *Paradise Lost* depicts the serpent as masculine, but as sinuous and beautiful. He says;

> Oft he bowed
> His turret Crest, and sleek enamel'd Neck
> Fawning, and lick'd the ground whereon she trod
> His gentle dumb expression turned at length
> The eye of Eve to mark his play.[5]

If the serpent had been ugly and frightening (as snakes are to most of us), would Eve have been tempted at all? The serpent is made to appear innocently attractive because evil is seductive. It is therefore, surely possible, that the painters Masolino and Michaelangelo used a woman's face to express the inviting charm that evil sometimes presents. There can be no question that it was Adam, through whom, as St Paul says 'sin came into the world'. He stresses that is was through one *man* – and man here is gender specific (Rom. 5.12). Eve's act in eating the apple is presented as having less direct evil

consequences than Adam's: whether or not one sees that as a slight to women is a matter of taste.[6]

It is not possible to claim that no male, cleric or lay, has ever, in the history of the Church seen women as evil, nor is it possible to deny the fear of woman as castrator which is revealed by such works as the notorious *Hammer of Witches* in the late fifteenth century. It is merely to point out that the assumption that all texts betray those beliefs is unjustified. They were never enshrined either in Church teaching or mainstream practice.

Aquinas and Woman as a Defective Male

As part of the general accusation against the Church in the Middle Ages, we find Aquinas accused of describing woman as a 'defective male'. Along with many another, Ute Ranke-Heinemann repeats the allegation and deduces from it that from birth 'every woman already has a failure behind her'.[7] Professor Michael Nolan is able to correct this interpretation. As he says, it comes about by selective reading of the text and by a remarkable failure to understand the way in which Thomas Aquinas structures his arguments – on whatever subject. Following medieval custom, Aquinas sets out his thesis, rehearses 'objections' to it and answers them. Writing about the Genesis account of creation, his thesis is that Adam and Eve were both directly created by God, although Adam was fashioned from the earth and Eve from the substance of Adam. However, they are equally God's handiwork and 'Eve was not a child of Adam'.[8] He then spells out one of the 'objections' to this statement. The objection is Aristotle's declaration that a woman is not what nature originally intended to produce. The argument here is complex and Aristotle himself, who came from the pagan Greek world before Christ, is misinterpreted, as Nolan makes plain.

Neither Aristotle, nor Aquinas for that matter, had access to accurate scientific knowledge about human reproduction. Aristotle thought that the male semen acted as a catalyst in that the substance of the child

derived from 'highly complex material fashioned by the mother'. He believed that 'male semen contributes nothing to the substance of the offspring ... but starts the workings of this complicated female element which, stage by stage, becomes a child. Nevertheless, the male semen acts, and acting things produce something like themselves (for example, fire makes other things hot). Hence the semen 'intends to' or 'is meant to' produce a male child. That is the reason for the saying of Aristotle, which is often translated as 'The female is a defective male'. Nolan translates it as 'Congenitally, the female is, in a sense, an anomalous male.' However, far from endorsing this belief, Aquinas refutes it, thus answering the objection (taken from Aristotle) to his original statement.[9]

Whereas Aristotle was understood to say that a female is indirectly, rather than intentionally produced, Aquinas seeks to show that a woman is 'intentionally' produced and he gives several explanations for this. They do not stand up to modern scientific knowledge, but they made the point in his own day. He suggests that psychological factors in the parents may produce girl children, or that environmental factors may affect the sex of the child, or indeed that the stars may have an influence on the matter. Before we laugh too heartily at his ignorance, we should remember that some teachers of fertility awareness have found that boy children are more likely to be produced at one point in the cycle rather than another. And that tight jeans are thought by some researchers to be the cause of a low semen count! Professor Nolan points out that the Mississippi alligator produces male or female offspring according to the temperature of the eggs during incubation.[10] He describes Aquinas's method of debate as both refuting a statement directly, and conceding some part of an argument in order to clarify a major point. Nolan's essays should be required reading for all courses of women's studies.

Is Christianity against Pleasure?

Ute Ranke-Heinemann would probably endorse Swinburne's lines:

Thou has conquered, O pale Galilean
And the world has grown grey with thy breath.

as she characterizes Christianity as 'joyless'. Her book *Eunuchs for the Kingdom of Heaven*, opens with the emphatic assertion that it was not the early Christians who brought 'self-control and asceticism' to a pagan and sensual world.[11]

While it is certainly true that many writers in the classical world advocated a life of sexual continence, it is not easy to argue that the lives of the emperors Tiberius, Caligula, Claudius and Nero were models of asceticism or that they had no influence on the people of their time and this is reflected in the writings of Tacitus, Martial and others. Mystery religions were popular and the rites of Cybele which took place in springtime, involved frenzied dancing, during which the participants cut themselves. Some men would castrate themselves in order to share the divinity of the gods. That cannot be described as the style of a sober life.[12] In a throw-away line, Ranke-Heinemann says, as an example of the honest spirit of the age that 'pederasty had become less highly rated'. She quotes Michel Foucault here.[13] Roman law did not forbid abortion or infanticide; divorce was commonplace.

Ranke-Heinemann berates the Church for laying down restrictions on sexual activity and upholding celibacy as a direct expression of self-giving to God. She blames Augustine for the emphasis that the Church has put on children as the fruit of sexual union between husband and wife. While it is certainly true that, in our own time, there is a greater awareness of the loving bond between husband and wife than at earlier periods, and that the Church's teaching on marriage developed over the centuries, the importance of the expression of sexual love in marriage was not unknown in the Middle Ages. Nicole

Oresme, for one, was a French priest, writing in the mid-fourteenth century. He says:

> [I]t often happens that two young people, a man and a woman love each other in a special way by choice and with heartfelt joy, with a love that is reasoned, though at times not correctly reasoned ... Sometimes this is a chaste love and prepared for marriage. And if sin should enter in it, is a human fault ... The love of husband and wife is also *aimable*.[14]

Aimable for Oresme denotes 'friendship', 'love' and 'delight'.

Ranke-Heinemann is correct in her observation that the three New Testament passages on marriage do not refer to the procreation of children. She says that we do not immediately have to talk about children, when we talk of marriage on the basis of the New Testament references. It does not, however, diminish the importance of new human beings. To the Jews, a childless marriage was a tragedy and a disgrace; everyone knew already that children were the glory of marriage. Children are, after all, the possible and striking result of sexual congress, the fruit of love between the spouses. The Jewish tradition emphasized the value of children in the strongest possible way, chronicling the shame of Sarah, the wife of Abraham, childless until her old age; the yearning of Hannah, before God granted her a son, Samuel; and the joy of Elizabeth at the conception of John who became the Baptist. It is, perhaps, not insignificant, that immediately after the discussion on marriage, in Matthew 19, in which Jesus was challenged by the Pharisees to state his teaching on divorce, children are brought to him for his blessing.

For all her emphasis on children as one of the 'goods' of marriage, the Church never said that marriage was only instituted in order to produce offspring, nor that intercourse should not take place when there was no possibility of conception, either during the non-fertile part of the woman's cycle or beyond the menopause. From St Paul onwards, it was always stressed that

husbands and wives should not refuse each other. St Augustine himself mentioned three 'bona' or good things that marriage results in; children, faithfulness and the unbreakable bond. The faithfulness and the bond go beyond the time of child-rearing and last as long as life itself providing mutual comfort even in old age.[15]

Ranke-Heinemann does not value the concept of life-long, indissoluble marriage. She accepts the understanding of Matthew 19, which allows divorce in cases of 'unchastity', – the interpretation accepted by some Protestants. She notes and the *Catholic Commentary on Holy Scripture* points out as well, that the Pharisees asked Our Lord a question about divorce, because of the contemporary debate between two famous rabbis of the time: Rabbi Hillel taught that a man could divorce his wife for trivial reasons; Rabbi Shammai allowed it only on grounds of adultery. Jesus' disconcerting response to the question put to him by the Pharisees, 'Is it lawful to divorce one's wife for any cause?' that is, for any trivial reason, is to say that now that *he* has come, divorce is not to be permitted on any grounds whatever.[16] From our vantage point in history, we can see the justice of this.

Jesus' statement is strong and direct, but it includes the troubling phrase, usually translated 'except for unchastity'. The likelihood of Christ's casually contradicting his own teaching in a parenthesis must be remote. If the phrase 'except for unchastity' is taken at its face value, Christ's position would have been that of Rabbi Shammai and, though perhaps unwelcome to the apostles, would not have shocked them. It is clear from the text that they are deeply upset! They immediately start to mutter that if that is God's way, it is better not to marry at all. Jesus takes the matter on to a higher plain. The celibate life, he says, is not for everyone, but only for those who have, as a vocation, the ability to give all to God. 'There are eunuchs who have made themselves eunuchs for the sake of the kingdom of heaven' (Matt. 19.12).

Pope John Paul II is taken to task by Ranke-Heinemann for endorsing what is the obvious meaning of

this text. She thinks that it refers to the fact that Jesus had told the apostles that marriage was indissoluble and that he understood that some were not up to living a celibate life, after divorce. 'How pathetic', she says that those who uphold the celibacy of the priesthood are always quoting this statement.[17] However, Jesus' remark clearly refers to the apostles' grumbling that if divorce was impossible, marriage was not to be thought of! Jesus does not let them off; he emphasizes both that marriage is for life, and that celibacy is a calling requiring great generosity of spirit.

The exact explanation of the phrase 'except for unchastity' (Matt. 19.9) is not certain. The *Catholic Commentary on Holy Scripture* suggests that it could refer to a separation, so that the husband should not have to live with an unfaithful wife; alternatively, it could refer to marriage within the degrees of kinship forbidden by Mosaic law and in that sense, not a 'real' marriage.[18] In small communities, such unions were relatively common.[19]

Joy and Joylessness

Ute Ranke-Heinemann speaks of the 'old Catholic view' that all pleasure is sinful and adds that Jesus hated 'lust', which she implies was an error on his part. Oddly, she describes him as 'listless' sexually.[20] She describes Christianity as 'joyless' because the Virgin Mary could not enjoy sexual pleasure at the conception of her son – or even afterwards. This idea is so central to her thesis that she ends her book with the same assertion. She claims that women are, to this day, being 'violated by the false doctrine of the Virgin Birth'.[21]

When the great lexicographer and man of ideas, Doctor Samuel Johnson, was asked how he countered the ideas of Bishop Berkeley (that there was no proof of the objective existence of matter), he replied 'I refute it thus' and kicked the fender. One is tempted to supply a similar robust response to Dr Ranke-Heinemann.

Sexual pleasure is part of marriage, but it is not the whole of marriage. The feeling of delight – the dictionary description of 'joy' – which women experience in their children, is not dependent on the degree of sexual pleasure they had at their conception. For some, sexual pleasure is worth giving up for some greater goal, whether before running a race, or devoting one's life directly to God.

Our Lord's virginal conception was necessary because he was the Son of God and God is a spirit, not a man (as feminist writers like to emphasize). God is not like Zeus, who in legend turned himself into a bull or a shower of golden rain to produce his children. Sexual pleasure, in any case, is not merely a thing-in-itself, especially for women. It is tied up with emotions, with desire to be recognized as a person, not merely as a sexual object. It implies long-term commitment, because it is the most intimate gift one person can make to another, bearing in mind the potentiality of the act. Without that continuing 'yes', it is a violation and emotionally sterile. The woman is not likely to be thinking of these ideas while making love, but they are inherent. It is the denial of these elements that make the position of the prostitute so sad and unenviable.

Rosemary Ruether speaks of 'subjugation of access' to her body, so that she cannot explore its pleasures. She accuses the Church of teaching that birth is 'shameful', and that it is through 'sexual libido' that original sin is passed on; she is mistaken.[22] Our capacity for evil is handed on from parents to children – libido does not come into it. How can the act of birth be shameful, when that is the method by which Christ came on earth!

'Joy' does not appear to be the dominant emotion experienced by those icons of sexual freedom and modern life, the 'pop' star, the 'model' and the sybaritic millionaire. They are presented as world-class sexual athletes, but if newspapers are accurate (a debateable proposition for sure), their lives are marked by insecurity, restlessness and emotional highs and lows, none of which reflect the joy we sometimes observe in the

Christian lives of ordinary women and men, who have followed, with many a stumble, the path of the Lord, whether they are married or celibate.

There is an inevitable tension between what our heads counsel and what our feelings urge. St Paul himself describes it when he writes 'I am carnal, sold under sin. I do not understand my own actions. For I do not do what I want, but I do the very thing I hate' (Rom. 7.15 RSV). Our Lord says that there is joy in heaven at the repentence of one sinner. The Church associates real joy with closeness to God and freedom from the seven deadly sins, the first of which is pride!

The Individual versus Marriage

The mixture of attraction, excitement and generosity which lead a man and a woman to marry is not a settled matter and will inevitably change over their years together. They are two in one flesh, but they also develop as individuals; they have interests in common and concerns they do not share. The thrill of building up a home, and of the arrival of children inevitably give way to more plodding concerns, about holding on to a job, finding the right schools and keeping patience. Nevertheless, to look for excitement elsewhere solves nothing. 'The person's right to happiness will not be satisfied by divorce, because a divorce harms too many things that are essential to his or her happiness. It shatters his or her children's happiness; and that effectively undermines the divorced parent.'[23] This is as true for men as for women.

It is harder for mothers than for fathers to break their intimate relationship with their children and that shows that there is no easy identity between men and women as parents. It is a good thing that fathers now play a greater part in the day-to-day care of their children than earlier generations of fathers did (though there were always some who helped), but the reality of gestation and birth tie the mother more closely to her child in the early

years. Unfortunately, the women's movement has chosen to emphasize individuality at the expense of commitment in marriage. All choices begin with the will, and the old saying that 'Where there's a will, there's a way' embodies a truth.

We see a strange dichotomy between public awareness, of the harmful results of divorce and an enthusiasm for ever-easier divorce laws. It appears as if the culture of 'rights' has overtaken the idea of 'duty'. Shakespeare makes the clown, Lancelot Gobbo, say, sententiously, 'If two men ride a horse, one must ride behind'. Though otiose, this statement cannot be gainsaid. Similarly in marriage, when conflicts arrive between the spouses, one must give way to the other. One hopes it will not always be the same spouse whose wishes prevail. In a truly Christian marriage, the husband will love his wife as his own body and will understand her needs (cf. Eph. 5.28). The wife has to be sensitive to her husband as well, since men are also in need of reassurance and endorsement. Husbands and wives often have different approaches to decision making and it is the love between them and the goodwill they have for each other that helps them avoid conflict.

They do, however, need to have an unshakeable commitment to the marriage in ordinary circumstances. I doubt if many of us would equal the Jewish wife, who was dining in a restaurant with her husband, as the story goes, when his young mistress came in with his best friend and *his* mistress. Having adjusted to this uncomfortable encounter, the wife whispered to her husband 'Our girl is the prettiest'! We need something of that sense of solidarity to keep a marriage afloat – though I am not suggesting that wives have a duty to condone adultery. It is much harder to put up with difficulties, if there is an easy way out – especially, if it is offered with the blessing of society, if not the Church.

Mothers and Children

The young of the human species need a long period of rearing before they are ready to face life on their own. Puppies and kittens can leave their mothers at eight weeks, and after a few days of moping can 'get on with their lives', as the cliché goes. The young human being is probably not ready before the age of eighteen years to conduct his or her life as an autonomous person – and even then the break with parents is not, thank God, usually final. Human living is a complex matter. It is not, therefore, surprising to find that the human child needs time with his or her parents – most particularly the mother, after the nine months in which she has been the baby's total environment. The encroachment of other people and other elements must require some mental adjustment. Because, as individuals, we do not remember this stage of our growing, it is all too easy to dismiss it as unimportant. The Church, without laying down rules has, perhaps unconsciously, emphasized this basic bond by the depiction of Our Lady and her divine Son.

Women's employment is not, of course, a new thing. The Industrial Revolution led to new working practices for women, which involved being away from home and child. Leo XIII in his famous encyclical *Rerum Novarum* (The Condition of the Working Classes), written in 1891 stressed the importance of the working man's 'living wage', sufficient to cover the reasonable needs of a family and to enable women to spend time with their children when they are small.[24] Both secular and religious feminists see this as a waste of women's time, whereas, as we have seen, the very fabric of society may depend on the way in which children acquire the basic building blocks of their emotional lives.[25]

There is much contemporary research evidence that small children do best with their mothers at home and school children do better with mothers who work part-time, rather than full-time.[26] A survey of infant healthcare professionals from 56 countries endorsed the view that small children fare best with their mothers,

rather than in the artificial environment of daycare nurseries.[27] Unless there is real necessity, both mothers and children benefit from spending their time together. It is obvious that the agitated, pillar-to-post regime of many mothers and their sons and daughters – rushing to deposit the child with the baby-sitter, daycare nursery, or school and the reverse rush in the evening, is likely to leave the mother as fractious as the baby. Nor does it necessarily serve fathers well, because they return from their own labours to a domestic situation unlikely to be refreshing.

Daycare, contrary to popular belief, is not an early educative process. It often results in aggressive children, who have learned only to fight their corner. It does not help with speech development, because children can only learn speech from adults and nursery helpers are not there on an almost one-to-one basis. Wall-to-wall 'educative' toys merely provide a mechanical environment, when what the child craves is time with mum. Such mothers also miss a great deal, because contrary to what the newspapers tell us, the work of looking after a family is very varied, comprising elements of teaching, entertaining, nursing, cooking and policing with a very high level of affirmative response. It is tiring and has its moments of boredom, like any other work. It is certainly underrated. But even despite the continuing propaganda by working women journalists for women to go out to work plus Government propaganda that women are 'wasted' at home, many women, when asked later in life which were the best times, will say 'It was when the children were young!'

Results of Marriage Breakdown

On Saturdays, one often sees a bored man treating a rather sulky child to large Cokes, ice-cream and hamburgers. It is the icon of 'access day'; the divorced father providing 'quality time' for the son or daugher who lives with the mother. It is natural for the child to try to get as much

compensation as possible in terms of treats for the depriva-
tion of life with one parent, usually the mother, often while
having to share her attention with a second husband or
lover. It is easy to imagine the sense of dislocation that this
must cause a child. Home Office research confirms that
such children are 'more likely to turn to crime'. The quality
of relationships with parents, is seen to be the determining
factor. Young people, living with their natural parents, do
better in terms of avoidance of heavy drinking, drug abuse,
and the other criminal offences that often go with that kind
of behaviour.[28]

Brenda Maddox, writing in *The Times* in 1996,[29] said
that divorce brings new dangers and that young girls
were now more at risk from their mother's boyfriends,
than from their natural fathers. We still often hear
expressed in the media the assumption that marriage is
not a valuable institution. Yet divorce is painful for
adults, too, involving upheavals which often take their
toll in terms of health and stability. Furthermore, we
learn from the surveys conducted by the official Office of
Population Censuses and Surveys that second marriages
are even more subject to breakdown than first marriages.
It is no surprise to learn that cohabitation lasts even less
time than second marriages. We know this from cases
where children are involved. If a man and a woman
cannot bring themselves to make a public mutual
commitment in marriage, before family and friends, the
reality of it is likely to be in doubt.

Common Matters of Dissent

In general, feminist activists seek a weakening of the
marriage bond because they see marriage as inherently
constricting for women. They tend to present Christian
marriage as an invention of the Church, rather than an
institution endorsed by Christ. The first act of his public
life took place at a wedding. Marriage, as a covenant of
mutual giving, provides women and men with the
highest opportunities for personal development in love.

Marriage breakdown, on the other hand, can be seen to be a tragedy – certainly to children of the marriage, and often to one or other spouse.

Divorce, in our society is of course, a civil matter and has no bearing on the reality of a sacramental marriage. Our Lord spoke of divorce which included a religious right to marry again. Feminist writers ask for 'compassion' towards Catholics who remarry, even though their original marriage has not been declared null, and are thereby barred from receiving the Eucharist. *Catholic Woman*, the newsletter of the umbrella organization, the National Board of Catholic Women, under the Bishop's Conference of England and Wales reported, with apparent approval, that some of their members thought that people in irregular relationships needed the Eucharist most. The Eucharist, however, is not a magic potion, which produces grace by a formula. One cannot hope to receive spiritual benefits, while defying the teaching of Christ in a major matter. Neither is the Eucharist a reward for good behaviour and, although it is the greatest, it is not the only means of grace. God does not abandon human beings, nor does the church – and God alone gives judgement.

Western society is increasingly secular and pagan. We live in that society and are inevitably influenced by its mores and expectations. In sexual matters, we Catholics are virtually on our own, though we have many sympathizers with one part of our beliefs or another. We are not supported by society, which until about thirty years ago more or less expected sexual continence outside marriage, which disapproved of divorce, and which did not countenance homosexual acts or the taking of human life before birth. In human terms, one now needs much higher levels of faith and courage to live a Christian life, even though in the matter of other virtues, our society has some sympathy for Christian ideals.

Feminist theologians see the 'signs of the times' and want to change Catholic doctrine to suit. The Vatican II Document *The Church in the Modern World*, agrees that we should be aware of the beguiling 'spirit of the age' but

adds, significantly, that we need to interpret it in the light of the Gospels.[31] The would-be reformers choose to ignore the Church's guarantee of essential truth. If the history of the Church teaches us anything, it is that she could not have survived without the Holy Spirit, who, as Gerard Manley Hopkins wrote,

> ... over the bent
> World broods with warm breast and with ah!
> bright wings.[32]

Persecution, personal failure and indifference have not destroyed the Church. She has always clung on to the teaching handed down to her, though the barque of Peter has leaned sometimes this way, sometimes that, but has never overturned essential truths. Even in the times of publicly sinful popes in the later Middle Ages, no doctrine was denied – and one might suppose, they would have preferred to take adultery and fornication off the list of sins!

Thus it is that the Church cannot permit anyone deliberately to cause an abortion, because he or she kills a human being, albeit a small one. The new being is human, because the parents are human, and is alive, otherwise it would not grow. We have no right to take life, which comes from God. As we know, the contraceptive 'mini-pill', like the intra-uterine device and other so-called contraceptives, in fact 'reduces or prevents' the possibility of the implantation of new life in the womb and does not prevent conception. It is abortifacient.[33] Genuine contraceptives are barriers to the union of husband and wife – that union which is the deepest expression of the 'unity of the two'. So the Church cannot change that doctrine either.

There is no doubt that, because of the emotional pressures of child-bearing, not to mention financial worries and difficulties with housing, the concept of 'openness to life' has caused anxieties to married couples, especially in a time when small families are the norm and are considered socially responsible. Rubber and pharmaceutical companies have had an interest in researching and

manufacturing various methods of birth control, but until recently there was little concentration on understanding the woman's cycle of fertility. Nowadays, the natural physical signs of incipient ovulation can be understood and husband and wife together can be taught to recognize a time to embrace and, where necessary, a time to refrain from embracing. Women are infertile, rather than fertile, for most of their childbearing years. Marriage, however, is procreative as well as uniting and children remain central to the Christian understanding of marriage. It goes back to Genesis and the joy that a man, whether girl or boy, is born into the world.

By seeking an identity between women and men, and a similar freedom for both, would-be revisionists reject the work of the Creator, who made the difference between them. *Vive la différence!* The United Nations Convention of the Elimination of all Forms of Discrimination against Women (1981) really seeks to give women equivalence by the provision of contraceptive services as a right, necessarily backed up by access to abortion, because of the incidence of contraceptive failure. The convention wants women to be free from the responsibility of bearing children, making them more like men. Unfortunately, the carefree life that women are invited to emulate is, though possible for the man, damaging to him. It leads him to neglect his duties, and remain adolescent and irresponsible, weakening his ability to see women as persons, rather than objects. That kind of behaviour is anathema to most women, who want a faithful, loving, honest and protective man for a mate. Most men also want a woman who is faithful, loving and honest. It seems that both sexes are being cheated.

John Henry Newman wrote:

To be a Christian is one of the most wondrous and awful gifts in the world. It is, in one sense, to be higher than angel or archangel. If we have any portion of an enlightened faith, we shall understand that our state, as members of Christ's church, is full of mystery. What so mysterious as to be born, as we are, under God's

wrath? What so mysterious as to be redeemed by the death of the Son made flesh? What so mysterious as to receive the virtue of that death one by one through sacraments? What so mysterious as to be able to train each other in good or evil? When a man at all enters into such thoughts, how is his view changed about the birth of children! In what a different light do his duties, as a parent, break upon him! The notion entertained by most men seems to be that it is a pleasant thing to have a home – this is what would be called an innocent and praiseworthy reason for marrying – that a wife and family are comforts. And the highest view a number of persons take is that it is decent and respectable to be a married man. All this is true ... But a man who limits his view to these thoughts, who does not look at marriage and the birth of children as something of a much higher and more heavenly nature ... who does not discern in Holy Matrimony a divine ordinance, shadowing out the union between Christ and the Church, and does not associate the birth of children with the ordinance of their new birth, such a one, I can only say, has very carnal views.[34]

Notes

1. Cf. Paul Ableman's perceptive treatment of male and female sexuality in *The Doomed Rebellion* (Zomba Books, 1983).

2. Ute Ranke-Heinemann, *Eunuchs for the Kingdom of Heaven* (Penguin, 1990), p. 139.

3. Olwen Hufton, *The Prospect Before Her* (Harper Collins, 1995), p. 29.

4. Hufton, *Prospect*, pp. 25–6.

5. John Milton, *Paradise Lost*, IX, 524–8.

6. It is only fair to note that Hufton is not writing as a Catholic. In later chapters of the same book, she shows great understanding of the development of religious orders for women in the seventeenth century.

7. Ranke-Heinemann, *Eunuchs*, p. 184.

8. Michael Nolan, 'The Defective Male: What Aquinas really said' (Church in History Information Centre, n.d.), with author's permission.
9. See *Summa Theologiae*, 1a, Q. 92, art. 1 ad 1.
10. Cf. Nolan, 'Defective Male', p. 24. Professor Nolan also brilliantly dismisses two other myths – that the Council of Mâçon held that woman does not have a soul and that Aristotle said that a female is a deformed male.
11. Ranke-Heinemann, *Eunuchs*, p. 9.
12. Thomas Bokenkotter, *A Concise History of the Catholic Church* (Doubleday, 1977), pp. 34ff.
13. Ranke-Heinemann, *Eunuchs*, p. 10.
14. Fabian Parmisano, OP, 'Love and Marriage in the Middle Ages' (Church in History Information Centre, n.d., reprinted from *New Blackfriars*, 1969, 599–608) with permission.
15. Cf. Cormac Burke, 'St Augustine and Conjugal Sexuality' in *Communio*, Winter 1990, 545–65, p. 549 with author's permission.
16. Cf. *Catholic Commentary on Holy Scripture* (Nelson, 1953) p. 885.
17. Ranke-Heinemann, *Eunuchs*, p. 33.
18. *Catholic Commentary*, p. 885.
19. Theodore Makin, *Marriage* (Paulist Press, 1982), p. 39.
20. Ranke-Heinemann, *Eunuchs*, p. 4. Is the translation slightly misleading here? 'Lust' in English means the desire for sex without love (cf. *Longman's English Dictionary*). Lust is seen as destructive and the word is a negative one. In German, the word 'lust' means a desire to do *something* and is not necessary to do with sex at all (cf. *Oxford Duden German/English Dictionary*). Similarly 'listless' in English means without energy or interests – not an epithet that can be easily applied to Christ!
21. Ranke-Heinemann, *Eunuchs*, p. 348.
22. Rosemary Radford Ruether, *Sexism and God-Talk* (SCM Press, 1983), p. 259.
23. Cormac Burke, *Covenanted Happiness* (Four Courts Press, 1990), pp. 64–65.
24. Leo XIII, *Rerum Novarum* (Catholic Truth Society, 1926), p. 40.
25. This is not an absolute. Circumstances, even strong inclinations, may make a mother's work outside the home the best for all concerned. Other things being equal,

142 *The Inner Goddess*

however, it is best for mother and child to spend those years together. Modern working practices again often make it possible for women to work at home or part-time.

. Cf. Patricia Morgan, 'Who Needs Parents?' in *The Hidden Cost of Child Care* (Institute of Economic Affairs, 1995), esp. pp. 21ff.
27. Dr P. Cook, *Early Child Care, Infants and Nations are Risk* (News Weekly Books, Melbourne) quoted in *Full Time Mothers*, Spring 1997.
28. Cf. *Evening Standard* report, 18 January 1996.
29. *The Times*, 29 May 1996.
30. *Catholic Woman*, Summer 1997.
31. Second Vatican Council, *The Church in the Modern World*, 4.
32. G. M. Hopkins, 'God's Grandeur', *Collected Poems* (Oxford University Press, 1948), p. 70.
33. Cf. *The Pill and Sex* (Medical Education Trust, n.d.).
34. J. H. Newman, *Parochial and Plain Sermons* Vol. 3 (Longmans Green, 1891), pp. 298–300.

9

'Green' Concerns

Annihilating all that's made
to a green thought in a green shade.
Andrew Marvell

Should we care for the earth? Of course, we should. Should we be concerned for the environment of our lives? We are stewards of the world, not careless owners; we must use our brains to make it a fit place for people to live in. The physical world, so amazingly wrought, so full of variety in shapes, contours and colours, in climate, in the things that grow and the creatures that move through their habitats, is a resource an endless wonder, and a solace for human beings. No wonder we are told in Genesis that 'God saw that it was good' (Gen. 1.3–31). When he had created man, and given 'them' dominion over everything, Genesis tells us, he saw that it was 'very good'.

The tradition of Christianity has been that of Genesis. All creation was given to man for his use. In Paradise, he was to care for the garden. After the Fall, he had to subdue the earth, in order to earn his bread. The farmer and the gardener have traditionally had a deep, symbiotic relationship with the land they cultivate and the animals they nurture. It has not, however, been a sentimental one. It has had its limits in the need for food and the need for money. Feminist writers, on the other hand, tend to personify nature and natural objects in order to pay them, as it seems to me, an inappropriate homage.

143

Ruether, for instance, speaks of a voice, long silent, but now being heard again – the 'voice of Gaia', whom she describes as our common mother, presumably Mother Earth, though she admits that it is really our own voice we hear.[1]

A play-acting animism is sometimes to be discerned among these writers. Animistic religions have a long history in primitive societies, with every plant and tree lived in by its own arbitrary spirit, to be placated or coerced by magic. Cardinal Joseph Ratzinger says that in Africa conversion to Christianity is often seen as a liberation from fear. 'The peace and innocence of paganism is one of the many myths of our day.'[2] However hard the moral tenets of Christianity are in practice, they have an inner coherence which can be understood.

Christianity is based on the belief that God made man in his own image, so that every man, male and female, bears a likeness to the Almighty. It is God and God alone whom we adore and we are grateful to be able to use the good things he has given us, in order to fulfil the purposes for which we were made; as the *Penny Catechism* put it 'to know him, love him and serve him in this life and to be happy with him forever in the next'. That is, in itself, to live for the greater glory of God.

Pagan Resources for Feminist Theology

In an essay called 'Immanent Mother', Meinrad Craighead identifies her creativity both with her mother and her God. She recalls that, when she was 7 years of age, she looked into the liquid eyes of her dog and interpreted water as the defining element – both mother and immanent God. She believes that there are many stories of god worshipped as mother. Certainly, there are some legends of this kind, notably the Sumerian creation story, but it has to be said that they tend to finish in the defeat of the goddess. In the primitive statue of the so-called Venus of Willendorf, a pregnant figure, she claims to have recognized the god she wished to acknowledge. She

believes that a woman, seeking the mother god within her, opens herself up to the world of nature and to forces larger then herself, though she sees these as situated inside her and not dependent on anything outside. It is not surprising that, in later years, Craighead left the religious life she had embraced; she found it impossible to pray to a God presented as male or to be subordinate to male clergy.[3]

Rosemary Radford Ruether points out correctly that the history of Christian thought includes influences from other than Judaeo-Christian sources – Greek philosophy, for example. She sees this in terms of providing other resources for the imposition of 'patriarchal' arguments. In an effort to overcome 'Christian patterns of bigotry' she led a service in which the goddesses Cybele, Ishtar, Anath, Isis and Gaia (rather an eclectic lot) were invoked and worshipped in her Methodist College.[4] In the first century, St Paul himself neatly used the Athenian cult of the Unknown God in his address to the Council of the Areopagus. The early Church adopted the winter feast of Saturnalia and Christianized it, to celebrate the birth of Christ. Christians took over pagan places of worship and turned them into churches. The bishops of the day well understood man's need and capacity to worship. They baptized pagan concepts: Ruether seems to have tried to paganize Christian worship.

Sr Madonna Kolbenschlag, in her exotically named book *Kiss Sleeping Beauty Goodbye*, sees the goddess movement as part of the evolution of faith – one which is postulated to change God himself. Her aim is to get rid of the idea of God the Father, and to do this, she believes it is necessary to use matriarchal imagery. She thinks women still need the help of old stories of goddess worship, and some form of white witchcraft – despite having kissed Sleeping Beauty goodbye. Her hoped-for goal seems to be a state of individual autonomy, in which women will do what they want and everything will be all right – a fairy-tale solution indeed.[5]

Rosemary Radford Ruether shrewdly enough cuts through some of the sentimentality of the goddess

worshippers by admitting that the treasured view of many feminists that early pagan societies were matriarchal is historically inaccurate and idealogically distorted. In *Woman-Church*, she writes rather wistfully that perhaps, lost in the mists of time, there was an earlier religion in which women were seen as persons, not as mother or whore, goddess or demon.[6] It is odd that she missed the Christian claim that Our Saviour died for each one of us as individuals – each woman as well as each man, each with our unique strengths and weaknesses. Like Kolbenschlag, she believes that feminist thelogies are the richer for pagan resources, and she also seems to imply that women need fairy stories to bolster their self-esteem. She is aware that paganism provides a romantic revolt against what is perceived as the moral straight-jacket of Christianity, but although she says she shares many values with the feminist 'wicca' or goddess religion, she is too honest to accept it without reservations.[7]

In a very pertinent letter to the *Coastal Observer*, an Indian newspaper, Dina Nanvutty writes that it is absurd for Indian feminists to claim that if the Catholic Church is rid of patriarchal attitudes it will make a difference to the sufferings of Indian women, because male influences will be diminished. Many atrocities are committed by those who worship Hindu goddesses, like Kali, Durga, Laksmi and so on. Murderers and rapists are not converted by them.[8]

'Green' Feminism

Just as one strand of feminism follows an individualistic agenda, another follows a 'green' path. The earth is always characterized as female, understandably, because the earth harbours and shelters growing seeds and roots within itself. Rosemary Radford Ruether writes, tautologically, that we need 'healing therapies' in order to fuel our love for 'Gaia'. That is Professor James Lovelock's name for the earth seen as having some ability to order or balance itself, so that the exacting conditions necessary

for life are always maintained. According to Robert Whelan, Professor Lovelock does not endorse religious worship of Gaia, but the temptation has been too strong for others, particularly perhaps feminist religious writers, who have fallen on the concept. It provides them with both a female object of worship and a view that is close to pantheism.[9] What was given to us for our use has become a deity, and for many feminists a goddess.

In the Postscript to her book, *Sexism and God-talk*, Rosemary Ruether speaks of women being alienated from their bodies, and from what she describes as 'our roots' which she places, rather oddly, in sky and water, as well as, more colourably, in the earth.[10] She maintains that we are lied to when we are told that we are strangers on this earth and that our flesh, blood and instinct for survival are our enemies: that a million witches were burned, being made to suppress their sexual instincts in order to 'fly away' to the stars – an attack, one supposes, on the Christian idea of transcendence. The book ends with an invocation of '... the empowering Matrix: She, in whom we live and move and have our being – She comes; she is here.'[11] Where?

With the light of the Easter candle shining in her eyes, Meinrad Craighead stated that she and those wth her, were signed with the earth symbols of the 'divine Generatrix.[12] This statement seems oddly placed in face of the rather masculine imagery of the Paschal candle immersed in holy water – a ritual which shocked a contributor to the *Catholic Women's Network Newsletter*.[13] She quotes a priest who is alleged to have seen his role as 'impregnating the congregation' – albeit on behalf of Christ after the resurrection. The 'fertility ritual' of the Easter vigil must not be overstressed: it appears simply to emphasize the new-birth of Christ's resurrection. Craighead describes 'Our Mother' as having only one law, which is 'to make' as 'she makes'. However the writer says that she continues to believe in the Christian mysteries.

These women exhibit tremendous anxiety about the condition of the earth. Ruether says that women must

also criticize 'humanocentrism', because to make human beings more important than animals or plants is unjust to them. She sees every species as having equal importance and validity. Seeing mankind as just another animal among many could hardly be further from the Catholic Christian tradition, which recognizes the supreme stature of man in creation.[14] But Ruether's recommendations for the betterment of the material world are rather sparse and do not go beyond re-using plastic bags and banning (as soon as possible) the use of fossil fuels. She has one recommendation, however, and that is that populations should be controlled for fear of famine and disease.[15] She seems quite unaware that the diagram of the single cake to be divided into smaller and smaller slices, is a flawed image for human development. The World Bank itself says that food production has more than kept pace with population growth.[16] As we all know, farmers in the rich world are paid not to produce food! Like most 'greens', she ignores these facts, and the fact that the dates by which various essential elements are to be exhausted recede ever further into the future.[17] Nor does she acknowledge that humanity, with its intelligence and initiative is, to use Julian Simon's phrase, 'the ultimate resource'.

In a rather touching, though it must be said, unrealistic passage, Ruether describes women's struggle as an attempt to humanize people, to save the planet and to be in a proper relationship with the 'God/ess'.[18] Madonna Kolbenschlag claims to see the goddess movement as a stage in the evolutionary process of both man and God – the God who is coming-to-be. However, though she sees goddess worship and witchcraft as 'helpful', she believes that in the end God will be 'liberated', the Church will wither and prayer will be understood as the deepest contact with the self.[19]

Kolbenschlag remarks that patriarchy is embedded in Genesis, and that there are other myths available. In a talk she gave in 1986 she alleged that the snake was a symbol of the goddess of fertility in the ancient world and thus of female power and its threat to the male. This is a

proof, she claimed, that Adam and Eve's sin was sexual and that God punished women by forbidding them from exercising power and from free and autonomous expression of sexuality. She went on, as her audience (a conference on Women in the Church), chuckled '... the abortion controversy is not about life. It's about control over women's sexuality and power.' The banishing of the snake, she said, is the banishing of the goddess.[20]

Another conference in America, reported in the *Catholic World Report* included a bread-blessing ritual and a blessing of 'the Cup'. Both avoided any reference to the deity, but the spirit of Sophia was invoked. Sophia, is, of course, a name for the Spirit of wisdom, but those invocations, sounding like the Divine Praises invoked 'Sophia's sisters', described as keeping alive the discipleship of equals. This was followed by an all-woman dance, with cash bar.[21] An allied theme of the conference was a pledge by participants to work for freedom of sexual and reproductive 'choices' for all. Most of these participants were nuns.

Catherine Halkes, in her book *New Creation* writes of a vision of the future – a glistening figure 'working' with chaos, while a white bird hatched new life.[22] There is, on this evidence, greater difficulty in inventing new myths, than in believing old doctrines.

Notes

1. Rosemary Radford Ruether, *Gaia and God* (Crossroads, 1992), p. 254.
2. Joseph Ratzinger with Vittorio Messori, *The Ratzinger Report* (Fowler Wright Books, 1985), p. 138.
3. M. Craighead, 'Immanent Mother' in E. E. Giles (ed.), *Feminist Mystique* (Crossroads, 1989), p. 71.
4. Rosemary Radford Ruether, 'Report from Institute on Religion and Democracy' in *Crisis*, September 1995, p. 6.
5. M. Kolbenschlag, *Kiss Sleeping Beauty Goodbye* (Doubleday, 1979), passim, especially pp. 166-202.
6. Rosemary Radford Ruether, *Woman-Church* (Harper & Row, 1985), p. 10.

7. Rosemary Radford Ruether, *Sexism and God-Talk* (SCM Press, 1983), p. 41.
8. Cf. *Coastal Observer*, India, March 1997.
9. Cf. R. Whelan et al., *The Cross and the Rain Forest* (Eerdmans, 1997), p. 47.
10. Ruether, *Sexism*, p. 259.
11. Ruether, *Sexism*, p. 266.
12. Craighead, 'Immanent Mother', p. 81.
13. Quoted in *Catholic Women's Network Newsletter*, September 1996.
14. Ruether, *Sexism*, p. 20.
15. Ruether, *Sexism*, p. 263.
16. *Sunday Telegraph*, September 1994.
17. J. Kasun, *The War against Population* (Ignatius Press, 1988), passim.
18. Ruether, *Sexism*, p. 46.
19. Kolbenschlag, *Sleeping Beauty*, pp. 171–2.
20. Kolbenschlag, quoted by Donna Steichen, *Ungodly Rage* (Ignatius Press, 1991), p. 148.
21. K. Howley, 'Strange Sisters', *Catholic World Report*, January 1996, pp. 30ff.
22. Catherine Halkes, *New Creation* (SPCK, 1991), p. 154.

10

The Inner Goddess

We are she ... we are the Christa.
E. Schussler Fiorenza[1]

In the light of my explorations, how has feminist theology revealed itself? I have first of all to admit that this work is no more than an overview. There are many feminist theologians and writers whom I have not quoted and many more I have not read. There is a very high incidence of published works emanating from theological departments of universities. Nevertheless, I have discovered a remarkable consistency underlying much of their work.

Despite their energy and self-assertion, there is a discernible sadness about their writings. They labour, year by year, chalking up a victory here, a sympathetic appointment there, but as far as Catholicism is concerned, they are aware that little changes and the essential doctrine of Christianity remains as it was. In 1987, some feminists in the USA declared that they would no longer support the age-old collection for the Pope's charities, called Peter's Pence, but they would institute Mary's Pence (Our Lady getting a rare look in), which was to fund the ministries of women. Rosemary Radford Ruether boasted at the Woman-Church Convergence that year that Mary's Pence would dry up the Vatican funding of oppression round the world.[2] Alas for human aspirations! The finances of the Holy See suddenly took a turn for the better and since 1992 have been consistently in the black, after 22 years in the red![3]

For all their stated concern with the downtrodden, feminists often appear to be more interested in the

151

struggle than in any possible outcome that would benefit the alleged sufferers. Indeed, mention of 'false consciousness' implies that those who are oppressed are better off knowing how badly treated they are, rather than living in comparatively blissful ignorance.[4] To make people aware of their injuries, when they did not know they were hurt, is to take on a great responsibility indeed. It is ludicrous to assert that all women in every Christian century have everywhere been downtrodden and miserable.

It may be that the bitter tone we hear, time and again, derives from a feeling of hopelessness. Their religious formation as Catholics, must, at one time or another, have shown them that the doctrine of the Church will never change. In spite of that, thousands of nuns, at least in the USA want to espouse a totally different Church, in order to worship a different God – under the same name. Many of them do not want to cut their links with the Catholic Church. Most of them are Church professionals of one sort or another, and cynics would say they like their pay-packets.[5] They may believe that they have a mission to reform the Church's structures from within, and some of them seek a democratic Church – although, if truth *were* to be decided on the basis of one Catholic one vote, feminism might find itself no better off than it is now! The tone of their writings and speeches does not suggest a totally altruistic position.

We have chapter and verse for the catalyst that started many nuns in the United States on a different path after Vatican II. The document on the religious orders told them to think about the future of their communities and how best to do their apostolic work. Unfortunately, the distinguished American psychologist, Dr Carl Rogers, along with Dr William Coulson believed that men and women could trust themselves to do good, without reference to Christian teaching or anything else. It was a question of looking within and following their inner promptings – their consciences would do the rest. Consciences, however, are fragile. The two psychologists, helped by an academic team, involved a number of convents in their schemes of 'therapy for normals'. The

nuns looked inside themselves, liked what they saw, and within a year half of the six hundred who took part in the programmes petitioned Rome to be released from their vows. They did not want to live under external authority. Dr Coulson has worked ever since to alert others to the terrible mistakes that were made by him and Rogers. Some of those who stayed may well have been disaffected as well.[6]

It is significant that many of the feminist theologians whose works I have read are not interested in the question of women's ordination because they do not believe in the sacraments and want a Church, in as far as they want one at all, in which metaphors for personal development and self-actualization are acted out. Karen Armstrong's thesis that women should be ordained has a period ring. In any case, the *Catechism of the Catholic Church*, says clearly that the ordination of women is not possible.[7] Many feminist theologians, lay as well as religious, show signs of being unable to accept their sexuality and this amounts to an *ontological* unease; a denial of the very depths of their being. God gave them their feminine nature and to reject it or reinterpret it in essence, is to live an anomalous life.

As we have seen, the main thrust of their interest is the promotion of women's position in society, which they believe to be harmed by religious structures, mirrored in the secular world. Many of them want, not merely an equality, however defined, with males, but an identity with them. The Church, they feel, gives them no voice and does not counter what they see as their biological disadvantages. Patriarchy is an excuse for bullying and women are tied to demeaning domestic jobs. Of course, it goes without saying, that given education and the assistance of technology (mostly invented by men, one must add) women are as capable of doing most jobs as men are. The feminist complaint is that men organized everything, that Christianity followed Judaism and still denies the best jobs to women. Unfortunately, the historical perspective of many of these writers is so narrow, that they fail to register the fact that most men had equally

humdrum daily tasks to perform and whether it was more desirable to be out in rain and cold digging mangels, or at home, stirring the pot by the fire, is a moot point. Very few men were kings, or generals, or cardinals.

A few years ago, a newspaper reported that women were going to be allowed to work underground in the US mining industry. It also reported the comment of a woman, in Soviet Russia, who said 'We've worked in the mines: we have had the experience: we want to stay home!' One of the saddest newspaper photographs I have seen showed a young American woman soldier in battle dress, ready to go to fight beside the men in the Gulf war. She was cradling her twelve-week old baby in her arms and bidding him farewell. Feminist writers give little emphasis to anything but public life, as if the hours of office or factory or university lectures were all important. That is not true even for most men. They care for personal relationships, for their families, even for their refreshing leisure activities.

Women who work outside the home, at any stage in their lives, whether they do it from choice or necessity, or a mixture of both, often retain a very strong pull towards home life, which represents the scene of their strongest feelings and affections. This is the stuff of ordinary observation, as well as academic research, and much popular fiction read by women shows the same level of involvement. The centrality to women of the world of affective emotion is reflected by their very biology. The only certain biological watershed that every male experiences, is the time when, as an adolescent, his voice breaks and his beard grows. A woman comes to the age of childbearing, and thirty to forty years later she leaves it and whether she actually bears children or not, she is reminded of her potential with every month that passes. The way in which her body prepares her for the birth of children also helps her, in non-physical ways, to bring her gift of womanhood to whatever circumstances she finds herself in, at whatever age she may be.

Catholic feminist theologians do not bring much

enthusiasm to considering married couples and their children (and wider family) as the 'domestic church'. Their concerns are rigorously individualistic. They largely reject any moral framework which does not chime with their personal experience and desire for personal autonomy. Time and again, the importance of their own history is brought in as the defining element in the way they live their lives. If people actually lived by this criterion, the world would be in chaos, unable even to define a framework for driving on one side of the road rather than the other. To counter this, some feminists like Rosemary Radford Ruether say that the experience of all women is the same; others like Mary Grey claim women have different experiences, but they are all experiences of oppression. Many feminist theologians do not understand the beauty of the Church's teaching on marriage and family, seeing it as merely restrictive and geared to the advantage of the male. Some like Kathleen Sands and Ute Ranke-Heinemann regard sexual pleasure as its own justification, regardless of context. In reality, Christian doctrine is formative for both women and men, enabling them and encouraging them to grow as persons in the security of lifelong marriage. They learn mutual self-giving in the certainty of willed love, not solely in the love of sexual attraction, or even shared interests, but in the intention to build an edifice called home and family, the domestic church – an intention which, with God's grace, is richly rewarded. If men lose the desire to protect and support their wives and children, and if women lose the ability to see that the gift they are given in their ability to have children is wonderful, then, of course, the hard work of every day life will seem merely restrictive, and breaking down the marriage and even taking the lives of children in the womb will be seen as merely utilitarian.

Children are a great good, but there has to be a certain measure in all things. Even the good of having children does not justify the grotesque manipulation of the building blocks of human existence and the ever more convoluted variations of *in vitro* fertilization. All human beings have a right to life and beyond that, the right to be

conceived through the union of father and mother, without the intervention of a technician, let alone the use of eggs and sperm from different sources. The freezing of human beings at the embryo stage and their subsequent defrosting for use or destruction at a later date shows no understanding of the value of human life.

To speak up for marriage and family life and, above all, pre-born humanity in our society is to become an object of ridicule among 'formers of opinion' and many legislators. It is noticeable that many Catholic feminist writers are, at best, tepid in support of these matters, which are at the heart of the Christian life of most people. Many of these writers urge us to look within. If we remain quiet, they say we will discern the truth within ourselves. It is indeed true, that the voice of God speaks to us in the silence of our own hearts. The difficulty is to distinguish between his voice and the promptings of our self-will. Since the 'aboriginal calamity', to use Newman's phrase, we are likely to hear what we want to hear. We can only make the distinction with certainty if we line up our inclinations with the teachings of Jesus, following him rather than our own desires.

In the acting out of feminist religious beliefs, participants typically tell their stories, share their tales of the bad treatment they have received, sometimes interspersed with 'roly-poly sessions' ending in wild giggling – according to reports in the *Catholic Women's Network Newsletter*. The Network wrote to the Cardinal Archbishop of Westminster ('Dear Basil Hume', they wrote) and invited him to listen to their stories and to tell them his stories, too![8] As they clearly state, their theology is centred, not on God, but on women. Thus their 'liturgies' involve much autobiography, play-acting, invocation of indeterminate 'spirits', and complaint. All this can easily slip into 'goddess' worship – or 'Godd/ess worship'. One can see that 'Thea(o)logy' is an awkward, but useful coinage, used by 'pro-sex' feminists.[9] To remove the element 'theos' from 'theology' leaves a vacuum, but it appears as if most of these writers omit the God-element

in favour of the study of self. By rejecting God the Creator, that is, God as mover, they come to see religious beliefs as metaphors of some vague system of personal fulfilment, with, sometimes, ethical overtones. Some, may indeed, believe in a female spirit, inhabiting mountain and glen, but it appears that most use the language of belief to reflect their pre-eminent concern with self.

The feminist writers whose work I have been considering have undoubtedly a thirst for justice, as they see it, and a concern, if a selective one, for the underdog. They also have intelligence, but their agenda is ultimately inward looking. Mary Grey admits that the immanent God should not be worshipped exclusively, but it is the deity within, identified by personal experience, invoked as the prime mover of 'self-actualization' that is the object of much feminist worship. As Madonna Kolbenschlag says, she believes that at some time in the future, prayer will be seen as the deepest contact with *self*. Even where feminists seek to change the Church, so that it becomes the obedient servant of their will, rather than the living body of Christ, they are, in effect, offering themselves as objects of their own worship. It is a seductive scenario. To worship God as wholly immanent in creation ultimately leads to the worship of 'self' – the 'inner goddess'. The 'inner goddess' is the female personification of the imperial self.

The Church offers everything to people of faith. The love of God is revealed, not just in a story, but in Christ himself, true God and true man, present to us in so many different ways. God went out from himself first to create us and our world and then, in the person of his Son to bring mankind back to him again. He did this with Mary as bodily mediatrix, mediating Christ in her own body and still interceding for us; the highest person in all creation – and a woman. We women have no need, therefore, to be ashamed of our sex. We have, inherent in our female personhood, qualities of self-giving that may even be seen to give us a head-start in sanctity!

At the end of this millennium, those of us who live in the rich world have so much. We are able to worship in

freedom in beautiful churches, without persecution. We can receive the sacraments. We have hitherto unimaginable opportunities for education, which we can turn to good, deepening our understanding of the faith and of the world and its peoples. We live longer and it is now rare for mothers to lose their children at an early age. We, our husbands, our children, our wider family and our friends have enough to eat and better medical attention than earlier generations had. We have, also, the loving and satisfying duty to work for God's kingdom in any way we can. We are threatened by our own society, but God's grace for the struggle is there for the asking.

Yet feminist writers 'begin' their theology, not in any attempt to discover the attributes of God, but by proclaiming Christian women's alleged oppression. This is often done with little attempt at historical contextualization. They are carried away by the sweep of their emotions and fired by their generalized rage. They cry 'It's not fair'. They are Cinderellas who never get to the ball. They waste their vigour and concern for the underdog in a pool of resentment, like Alice in Wonderland's pool of tears.

Christianity is seen by them as an endlessly disappointing series of metaphors for human existence. God becomes the 'God-problem', as Ruether names it. Unable to believe in him, she is still feeling the want of 'a vision of a source of life that is "yet more" than whatever presently exists.'[10] Feminist theologians and writers try to illuminate psychological patterns through religious symbolism, and are left, it appears to me, struggling in the straitjacket of their systems of thought. The inexhaustible riches of the faith, loved, savoured, studied and lived by women and men alike, in humility and fervour, with personal failure and personal triumph, seem hardly to touch them. Their religious horizons close in on them – whereas, outside, in the wide world,

All things counter, original, spare, strange,
Whatever is fickle, freckled (who knows how?)
With swift, slow; sweet, sour; adazzle, dim;
He fathers-forth, whose beauty is past change:
Praise him.

(G. M. Hopkins)[11]

Notes

1. E. Schussler Fiorenza, *Jesus, Miriam's Child, Sophia's Prophet* (SCM Press, 1994), p. 3.
2. Cf. D. Steichen, *Ungodly Rage* (Ignatius Press, 1991), p. 326.
3. Vatican Information Service, 10 November 1995.
4. Ruether, *Sexism*, p. 259.
5. Cf. *Catholic World Report*, January 1996, pp. 36ff.
6. Cf. William Coulson, *We Overcame their Traditions, We Overcame their Faith* (Michael Real), reprint from *The Latin Mass* Vol. 13, No. 1, Jan./Feb. 1994.
7. *Catechism of the Catholic Church*, 1577.
8. *Catholic Women's Network Newsletter*, March 1977.
9. Kathleen M. Sands, 'The uses of thea(o)logy', *Journal of Feminist Studies in Religion*, Spring 1992, pp. 8–21.
10. Rosemary Radford Ruether, *Gaia and God* (Crossroads, 1992), pp. 4–5.
11. 'Pied Beauty', *Collected Poems* (Oxford University Press, 1948), p. 74.

Bibliography

Ableman, Paul, *The Doomed Rebellion* (London, Zomba Books, 1983).

Allen, Prudence, 'Integral Sex Complementarity', *Communio*, Winter 1990.

Anselm of Canterbury, *Proslogion*, in Anton Pegis (e.d), *The Wisdom of Catholicism* (New York, Random House, 1949).

Aquinas, Thomas, *Selected Writings*, ed. Martin D'Arcy (London, Dent, 1940).

Aquinas, Thomas, *A Shorter Summa*, ed. P. Kreeft (S. Francisco, Ignatius Press, 1993).

Armstrong, Karen, *The End of Silence* (London, Fourth Estate, 1993).

Augustine, *Confession* (London, Collins, 1969).

Augustine, *De Catechizandis Rudibus*, trans. J. P. Christopher (New York, Newman Press, 1946).

Aumann, Jordan, *Christian Spirituality in the Catholic Tradition* (London, Sheed & Ward, 1985).

Bianchi, Eugene and Ruether, Rosemary Radford, *Towards a Democratic Church* (New York, Crossroad, 1992).

Bloom, Allen, *The Closing of the American Mind* (New York, Simon and Schuster, 1987).

Bokenkotter, Thomas, *A Concise History of the Catholic Church* (New York, Doubleday, 1977).

Bouyer, Louis, *Rites and Mankind* (Notre Dame University Press, 1963).

Bouyer, Louis, *Spirituality of the New Testament and the Fathers* (London, Burnes & Oates, 1963).

Bristow, Peter, *The Moral Dignity of Man* (Dublin, Four Courts Press, 1990).

Burke, Cormac, 'St Augustine and Conjugal Sexuality' in *Communio*, Winter 1990.

Burke, Cormac, *Covenanted Happiness* (Dublin, Four Courts Press, 1990).

Butters, John, *Fundamental Themes in Christian Ethics* (Birmingham, Maryvale, 1992).

Buytendijk, F. J., 'Woman, Nature – appearance – essence', in Hauke, *Women in the Priesthood?*

Byrne Lavinia, *Women Before God* (London, SPCK, 1988).

Catechism of the Catholic Church (London, Geoffrey Chapman, 1994).

Catholic Women's Network Newsletter, issues from 1989 to 1997.

Chesterton, G. K. *The Everlasting Man* (London, Burns & Oates, 1973).

Chesterton, G. K. *The Essential Chesterton*, ed. P. J. Kavanagh (Oxford, 1985).

Christian Women's Resource Centre, *Women Created Liturgies* (London, 1987).

Congar, Yves, *Tradition and Traditions* (London, Burns & Oates, 1966).

Congregation for the Doctrine of the Faith, *Letter to the Bishops of the Catholic Church on Some Aspects of the Church Understood as Communion* (London, Catholic Truth Society, 1992).

Copleston, F. C., *Aquinas* (Harmondsworth, Penguin, 1955).

Coulson, W. 'We Overcame their Tradition, We Overcame their Faith' *The Latin Mass*, Vol. 3, No. 1, January-February 1994.

Craighead, Meinrad, 'Immanent Mother', in E. E. Giles (ed.), *Feminist Mystique* (New York, Crossroad, 1989).

Christ, Carol, 'Mircea Eliade and the Feminist Paradigm Shift', *Journal of Feminist Studies in Religion*, Fall 1991.

Daly, Mary, *Gyn/ecology* (Boston, Mass., Beacon Press, 1978).

Donnelly, Dorothy, 'The Sexual Mystique' in E. E. Giles (ed.), *The Feminist Mystique* (New York, Crossroad, 1989).

Duggan, Fr., 'Inclusive Language or "Femspeak"', *Association of Catholic Women Review*, September 1996.

Elshtain, Jean Bethke, *Public Man, Private Woman* (Princeton, NJ, 1981).

Erikson, Erik, *Childhood and Society* (Norton, NY, 1987).

Figes, Eva, *Patriarchal Attitudes* (London, Macmillan, 1986).

Flannery, Austin (ed.), *Vatican II, the Conciliar and Post Conciliar Documents* (New York, Costello, 1982).

Frankl, Victor, *The Will to Meaning* (London, Souvenir Press, 1971).

Friere, Paolo, *Pedagogy of the Oppressed* (Harmondsworth, Penguin, 1972).

Green, Vivian, *A New History of Christianity* (Stroud, Sutton Publicity, 1996).

Grey, Mary, *Redeeming the Dream* (London, SPCK, 1989).

Grey, Mary, 'Claiming Power in Relation', in *Journal of Feminist Studies in Religion*, Spring 1991.

Gross, Richard, *Psychology, the Science of Mind and Behaviour* (London, Hodder & Stoughton, 1992).

Hahn, Scott, *A Biblical Understanding of Mary* (audiocassette) (W. Covina Cal., St. Joseph's Communications Inc. n.d.).

Hampson, Daphne, *Theology and Feminism* (Oxford, Basil Blackwell, 1990).

Halkes, Catherine, *New Creation* (London, SPCK, 1991).

Häring, B., *Full and Faithful in Christ*, Vol. 1 (Slough, St. Paul's Publications, 1978).

Hauke, Manfred, *Women in the Priesthood?* (San Francisco, Ignatius Press, 1988).

Hebblethwaite, Margaret, *Six New Gospels* (London, Geoffrey Chapman, 1994).

Hellwig, Monika, *The Compassion of God* (Dublin, Dominican Publications, 1983).

Holloway, Edward, *Sexual Order, Holy Order* (Wallington, Faith Press, 1984).

Hopkins, G. M., *Collected Poems* (Oxford, Oxford University Press, 1948).

Houlden, J. Leslie, *The Johannine Epistles* (London, A. & C. Black, 1995).

Howley, Kathleen, 'Strange Sisters' in *Catholic World Report* January 1988.

Hufton, Olwen, *The Prospect Before Her* (London, HarperCollins, 1995).

Ignatius of Antioch, *Letter to the Trallians*, in *Early Christian Writings* (Harmondsworth, Penguin, 1968).

Ignatius of Antioch, *Letter to the Romans* in A. Pegis (ed.) *The Wisdom of Catholicism* (New York, Random House, 1949).

Irigaray, Luce, 'Egales a Qui?' in *Critiques* 43 (1987).

Jeanrond, W., *Text and Interpretation: Categories of Theological Thinking* (New York, Crossroad, 1988).

John XXIII, *Peace on Earth* (London, Catholic Truth Society, 1979).

John Paul II, *Redemptor Hominis* (London, Catholic Truth Society, 1979).

John Paul II, *Familiaris Consortio* (London, Catholic Truth Society, 1982).

John Paul II, *The Pope Teaches* (London, Catholic Trust Society, 1982).

John Paul II, *Christifideles Laici* (London, Catholic Truth Society, 1988).

John Paul II, 'The Dignity of Woman' *Origins* Vol. 18, No. 17 (Washington, DC., 1988).

John Paul II, *Centesimus Annus* (London, Catholic Truth Society, 1991).

John Paul II, *Crossing the Threshold of Hope* (London, Cape, 1994).

John Paul II, *Tertio Millennio Adveniente* (London, Catholic Truth Society, 1994).

John Paul II, *Evangelium Vitae* (London, Catholic Truth Society, 1995).

John Paul II, *Letter To Women* (London, Catholic Media Office, 1995).

Joseph, Alison, *Through the Devil's Gateway* (London, Channel Four Books, 1990).

Jung, C. G., *Memories, Dreams and Reflections* (London, Collins, 1963).

Jungmann, J., *Early Liturgy to the Time of Gregory the Great* (Notre Dame, Ind., 1959).

Kasun, J., *The War against Population* (San Francisco, Ignatius Press, 1988).

Kelly, Christine (ed.), *Feminism v. Mankind* (Milton Keynes, Family Publications, 1980).

Kelly, Christine (ed.), *The Enemy Within* (Milton Keynes, Family Publications, 1992).

Kettle, Peter, *A Palm Sunday Liturgy*, (Association for Inclusive Language, n.d.).

Knitter, Paul, 'Towards a Liberation Theology of Religion' in J. Hick and P. Knitter (eds.), *The Myth of Christian Uniqueness* (Mystic, Conn., 1988).

Kolbenschlag, Madonna, *Kiss Sleeping Beauty Goodbye* (New York, Doubleday, 1979).

Kolbenschlag, Madonna, untitled talk in Women in the Church Conference, Washington, DC., 1986, in Steichen, *Ungodly Rage*.

Kopaczynski, Germain, 'Is Nature Misogynist?' in *Homiletic and Pastoral Review*, Jan. 1995.

Lawlor, R., Boyle, J., and May, W., *Catholic and Sexual Ethics* (Huntingdon, 1985).

Leo XIII, *Rerum Novarum* (Oxford, Catholic Social Guild, 1926).

Lobo, George, *Guide to Christian Living* (Westminster, Maryland, Christian Classics, 1991).

Lonergan, Bernard, *Method in Theology* (London, Darton, Longman & Todd, 1972).

Lonergan, Bernard, *A Second Collection* (London, Darton, Longman & Todd, 1974).

Lonergan, *Insight*, (London, Darton, Longman & Todd, 1983).

Lersch, Philipp, 'On the Nature of the Sexes' in Hauke (ed.) *Women in the Priesthood?*.

Maeckkelberghe, Els, *Desperately Seeking Mary* (Kampen, Netherlands, Phonos, 1991).

Marcolengo, Renzo, *Psychology in Relation to Personal, Moral and Spiritual Development* (Birmingham, Maryvale, 1992).

Maddox, Brenda, 'Tales as Yet Untold', *The Times*, 29 May 1996.

Makin, Theodore, *Marriage* (New York, Paulist Press, 1982).

Mannion, Francis, 'The Church and the Voices of

Feminism' in *America*, 1991.

Martin, Francis, *The Feminist Question* (Edinburgh, T. & T. Clark, 1994).

McEwan, Dorothea, 'The Praxis of Feminist Theology', in *Feminist Theology*, January 1995.

McDonald, Peter, 'Did St. Thérèse want to be a priest?' in *Homiletic and Pastoral Review*, April 1989, 7–21.

Maritain, Jacques, *Religion and Culture* (Sheed and Ward, 1931).

Medical Education Trust, *The Pill and Sex* (n.d.).

Moore, R., and Gillette, D., *King, Warrior, Magician, Lover, Rediscovering the Archetypes of the Mature Masculine* (S. Francisco, Harper, 1990).

Morgan, Patricia, 'Who Needs Parents?' in *The Hidden Cost of Child Care* (London, Institute of Economic Affairs, 1995).

Nesbitt, Roger, *Mary, Mother of the Church* (Faith Pamphlets, n.d.).

Newman, J. H., *Parochial and Plain Sermons* Vol. 3 (London, Longmans Green, 1891).

Newman, J. H., *Apologia Pro Vita Sua* (London, Longmans Green, 1909).

Newman, J. H., *Essays, Critical and Historical* in C. S. Dessain (ed.), *The Mind of Cardinal Newman* (Catholic Truth Society, 1974).

Newman, J. H., *The Grammar of Assent*, ed. N. Lash (Notre Dame University Press, 1979).

Newman, J. H., *The Idea of a University* (Chicago, Loyola Press, 1927).

Newman, J. H., *A Packet of Letters*, ed. J. Sugg (Oxford, Oxford University Press, 1983).

Nolan, Michael, 'The Defective Male: What Aquinas really said' (Church in History Information Centre, n.d.).

O'Carroll, Michael, *Theotokos* (Wilmington, Del., Michael Glazier, 1982).

Orchard, Bernard (ed.), *Catholic Commentary on Holy Scripture* (London, Nelson, 1953).

Orchard, Bernard, *Born to the King* (London: Ealing Abbey Scriptorium, 1993).

166 *Bibliography*

Orchard, Bernard, *The Origin and Evolution of the Gospels* (London: Ealing Abbey Scriptorium, 1993).
Ott, Ludwig, *Fundamentals of Catholic Doctrine* (Richford, Ill. Tan Books, 1960).
Parker, R. and Brows, J., 'Coming-out rite for a lesbian', in Ruether, *Woman-Church*.
Parmisano, Fabian, 'Love and Marriage in the Middle Ages' (Church in History Information Centre, n.d., reprinted from *New Blackfriars*, 1969, 599–608).
Pegis, Anton (ed.), *The Wisdom of Catholicism* (New York, Random House, 1949).
Plunkett, Dudley, *Communicating Values* (Birmingham, Maryvale, 1993).
Pontifical Biblical Commission, *On the Interpretation of the Bible*, in *Briefing* 1–19, February 1994; 22–15, March 1994.
Preston, Kevin, *The Church* (Birmingham, Maryvale, 1994).
Ratzinger Joseph, with Vittorio Messori, *The Ratzinger Report* (Fowler Wright Books, 1985).
Ranke-Heinemann, Ute, *Eunuchs for the Kingdom of Heaven*, (London, Penguin, 1990).
Rogers, J., Mackenzie, R., Weeks, L., *Case Studies in Christ and Salvation* (Philadelphia, Westminster Press, 1977).
Ruether, Rosemary Radford, *The Church against Itself* (London: Sheed & Ward, 1967).
Ruether, Rosemary Radford, *Mary, the Feminine Face of the Church* (London, SCM Press, 1979).
Ruether, Rosemary Radford, 'The Person and the Work of Christ', in Rogers, et al. *Case Studies*.
Ruether, Rosemary Radford, 'Women's Body and Blood' in Joseph, *Through the Devil's Gateway*.
Ruether, Rosemary Radford, *To Change the World* (London: SCM Press, 1981).
Ruether, Rosemary Radford, *Sexism and God-Talk* (London, SCM Press, 1983).
Ruether, Rosemary Radford, *Woman-Church, Theology and Practice* (San Francisco, Harper & Row, 1985).
Ruether, Rosemary Radford, *Gaia and God* (London,

SCM Press, 1993).

Ruether, Rosemary Radford, 'On Being a Catholic Feminist at the End of the Twentieth Century' in *Catholic Women's Network Newsletter*, December 1994.

Ruether, Rosemary Radford, and Merton, Thomas, *At Home in the World* (Maryknoll, NY, Orbis, 1995).

Russell, Letty, *Feminist Interpretation of the Bible* (Oxford, Basil Blackwell, 1985).

Sands, Kathleen, M., 'The uses of thea(o)logy', *Journal of Feminist Studies in Religion*, Spring 1992.

Saward, John, 'Thanks for the Feminine', *Association of Catholic Women* (December 1989).

Saward, John, *The Mysteries of March* (London, Collins, 1990).

Schneider, Sandra, *Beyond Patching* (New York, Paulist Press, 1991).

Schussler Fiorenza, Elisabeth, *The Discipleship of Equals* (London, SCM Press, 1993).

Schussler Fiorenza, Elisabeth (ed.), *Searching the Scriptures* Vol 1 (New York, Crossroad, 1993).

Schussler Fiorenza, Elisabeth, *Jesus, Miriam's Child, Sophia's Prophet*, (London, SCM Press, 1994).

Sheed, Frank, *The Church And I* (London, Sheed & Ward, 1974).

Snyder, Mary Hembrow, *The Christology of Rosemary Radford Ruether* (Mystic, Conn. Twenty Third Publications, 1988).

Steichen, Donna, *Ungodly Rage* (Chicago, Ignatius Press, 1991).

Tolhurst, James, *A Concise Companion and Commentary for the New Catholic Catechism* (Leominster, Gracewing, 1994).

Vitz, Paul, 'Support from Psychology for the Fatherhood of God' *Homiletic and Pastoral Review*, February, 1997, 7–19.

Weinandy, Thomas, *In the Likeness of Sinful Flesh* (Edinburgh, T. & T. Clark, 1993).

Whehelan, Imelda, *Modern Feminist Thought* (Edinburgh, Edinburgh University Press, 1995).

Whelan, R., Kirwan, J., Haffner, P., *The Cross and the Rainforest* (Grand Rapids, Eerdmans, 1996).
Willey, Petroc, *Marriage and Sexual Ethics* (Birmingham, Maryvale, 1992).

Index

169

and God in theology 3, 118, 158
and goddess spirituality 145–6, 148
influence 12
and Jesus 36–8, 53
and liberalism 15
and liturgy 83, 85–6, 88–9, 91–2, 93
and male and female 112, 113
and nature 11, 144, 145, 146–8
and objective sources for theology 7
and the Old Testament 31–2, 37
and ordination of women 103
and patriarchy 23, 24, 31, 116, 145, 151
and redemption 32–3, 53
and resurrection 47–8
and sexuality 69–70, 131
and theology and sociology 21
and the Virgin Mary 60, 61–2, 64, 66–8, 71, 72, 74–7
and women in the early Church 106
see also God/ess

sacraments
efficacy 92, 94, 108, 137
as instituted by Christ 83–4
sacrifice 43, 44, 49, 114
Sacrosanctum Concilium 84
saints
cult of 111 n.3
and ordination of women 109

salvation *see* redemption
Samaritan woman 56–7, 104
sanctification, self-sanctification 64
Sands, Kathleen M. 15, 155
Sandys, Edwina 43
Schaberg, Jane 61
Scheler, Max 115
Schussler Fiorenza, Elisabeth
and gender construction 112–13
and hermeneutic of suspicion 20, 23
and men and women 6–7, 10–12, 112, 113, 114
and the Old Testament 22–3
and ordination of women 106
and patriarchy 12, 23, 24, 116
and types of feminism 13, 14
scripture and tradition *see* Bible; tradition
Second Vatican Council
and inculturation 85
and lay ministries 103
and liturgy 82, 83–4
and marriage 71
and the modern world 137–8
and religious orders 152
see also Gaudium et Spes; Lumen Gentium; Sacrosanctum Concilium
self, in feminist theology 3, 9, 15, 58, 148, 156–7
service 26, 57, 117
sex education 12
sexuality
and asceticism 75–6, 127